Living –over– Existing

how to push past the mental barriers that
are holding you back from success

Alisha Robertson

This book is for the women and little girls who currently feel stuck in their own heads. Those who don't feel understood, the voiceless and the introverts.

I hear you, I see you, I am you.
Get ready to take over the world.

Alisha Robertson

Table of Contents

introduction

"Living in the moment means letting go of the past and not waiting for the future. It means living your life consciously, aware that each moment you breathe is a gift."
- Oprah Winfrey

Fearful, voiceless, and self-conscious.

I walked with my head down and my shoulders pointing to the ground, afraid to speak up out of fear of what others would think. I would pretend that I wasn't that smart in order to not seem like a know-it-all, and I acted as if I did not enjoy being in the spotlight when, deep down, all I really wanted was to be seen and heard.

I spent the first 25 years of my life fading back into the shadows, standing behind everyone else, crippled with fear, instead of standing up for myself, voicing my opinion, and pursuing the amazing, creative gifts God had blessed me with. Instead, I conformed to what others thought I should be while feeling completely disconnected from my true self.

I was existing.

I was wishing I had the courage to do something I

loved – something that fulfilled me and would help me to escape the cubicle life that made me feel like I was dying slowly. I was settling for whatever was handed to me and constantly apologizing for what I truly wanted to say and do. I allowed fear to stop me, and self-doubt to constantly tell me I wasn't good enough, and comparison made me ignore the good that was going on in my life because my good did not look like someone else's great or their picture-perfect Instagram feed.

I sat on the sidelines for years – in jobs I hated – and watched everyone else take leaps of faith, go after the careers of their dreams, and live life on their terms. I was a mess, both physically and mentally.

Full of ideas and creative talent, yet I wasted them due to not being able to push past my own issues...until I decided to surrender and allow God to use the gifts He had given me.

I knew if I could not fix myself, I needed to turn to the One who had the power. So, I decided to take a little leap of faith and began turning my idea into a real business (which we'll talk about more later). The first, utterly terrifying step, was not as painful as I had been telling myself it would be all of those years. I decided to take another step, and then one after the other, until I had built a brand that allowed me to share my purpose with the world.

I decided to live.

Despite the odds.

Despite the emotions, fears or what anyone else had to say about it.

I lived.

On purpose.

– *For me.*

Today, the online platform I have built has allowed me to uncover the purpose God has set for my life. This platform has given me hope and the voice I longed for my entire life. The young girl who was merely existing, going about her day-by-day life with no real purpose, is now a woman who is confident in who she is, what she wants, and what she's worth. I want you to know that my journey has not been easy, but being able to push past the fears, self-doubt and worry has been worth it.

I'll assume you picked up this book because you're ready to make a deep change in your life and take a shot at entrepreneurship. Or maybe you already run your own business and you are ready to take your plans a step further. No matter where you are in your entrepreneurial journey, you have made the decision that this year, or in this moment, you will take a chance on yourself and leap – that you want to truly begin living your life to the fullest instead of going through the motions, day after day.

Let me ask you something – What would your life look like if you finally put action behind all of those big ideas and built an actual, money-making business around your passions and purpose? Would you finally wake up with joy in your heart because you knew you were about to spend the day working on what you love? Would you have more time and money to spend on those you love the most?

Seriously, take a moment, close your eyes, and picture yourself in the moment. Visualize the work you will be

creating. Fill your mind with the happiness and appreciation you will feel for all of the amazing opportunities God will provide. Focus on the fact that He not only blessed you with an incredible purpose, but also the means for your purpose to financially support you and your family.

Now, what's stopping you from making this your reality? What's stopping you from living out your purpose and making a bigger impact and income? No, seriously, what is holding you back? And don't say that you don't know how to get started because we currently live in a world that is powered by Google. Everything you can possibly need can now be found at your fingertips. Plus, there are tons of online resources, coaches, and mentors who can show you the "how."

Let's look beyond getting started.

What if I told you that what stops most creative women from digging deeper into discovering their purpose and turning it into a real, profitable business isn't the lack of know-how? I've found that what holds most of women back are the different internal obstacles like fear, comparison, and self-doubt. Because of this, many creatives never make it past the idea stage. These obstacles also trap you into thinking that staying in your comfort zone is normal and safe; thus, you walk through life wishing you had the guts to do more than what the average human requires.

No expensive training, e-course, coach, or guru will matter, or even be able to help, if your mindset is out of whack. If you cannot decide to push past the thoughts telling you you're not good enough or your dream is too scary, you will not be able to effectively move forward.

I get it – you want to push past what has been holding you back and trust that God is going to use you in an incredible way, but something is stopping you. You feel your heart swell up with happiness and get that tingly feeling in your stomach every time you think about all of your amazing ideas of how you can build the brand of your dreams...but somewhere during that idea phase, right as you were mustering up the courage to take the leap of faith, fear rears its ugly head.

Next thing you know, you've been knocked down, five steps back and you are second guessing everything you have dreamed of. You know you have a God-given gift and talent, but you struggle to put your faith in Him instead of trying to figure it all out yourself.

So, you wait.

Wait for the perfect moment.

Wait for the perfect instructions.

Wait for permission.

If, in fact, you picked up this book because you're ready to change, then welcome! Get ready to reveal and change everything you think you currently know about yourself and what it means to be a successful business owner.

Please understand – this book will not teach you how to build a business or reveal how to become rich or famous.

You won't find that here.

This book was written to uncover the reasons why many creative women never take the leap of faith into entrepreneurship or do what is needed to take their existing brand to the next level. There are a ton of business

books that show you how to make more money, and how to impress your audience and be seen as an expert in your industry, but there are very few that share how to move past the mental blocks stopping you from moving past the idea stage.

Often we feel as though we can never be like the influencers we see with thousands of "likes" on Instagram or as popular as the ones sharing their big, powerful message through their blogs. And every time we see someone talk about how they made six figures in one month, we cringe a little on the inside. Thus, we hold back sharing our gifts in fear that we will be judged, we will fail, or we will never live up to the world's standard of what success is "supposed" to look like.

This book will guide you through uncovering your purpose and will provide you with practical tips on how to begin moving past some of those fears and frustrations.

Don't get me wrong – I certainly want this book to be the starting point of turning your purpose into a wildly successful and profitable business, but you cannot begin to move forward until you have figured out what has been holding you back.

You'll find that here.

You're probably thinking, "Alisha I've heard this all before," but trust me on this – everything I have mentioned I know because this was my life. I am you. The frustration you are currently feeling, I've been there – feeling voiceless in a world that is constantly chattering.

Trust me, I get it. I know how it feels to hit your breaking point but have no clue what to do next; to be so crippled

by fear and anxiety that you downplay your gifts in order to make yourself seem smaller than what you really are to avoid any type of attention or judgement.

I remember telling myself, for years, that if I didn't make a big deal about myself or anything I do that I could avoid disappointment from others. But the only thing I was doing was putting myself at a disadvantage and disappointing God.

If you take anything away from this book, know that I understand exactly what you are feeling and what you are going through. You are not alone. Those ideas you have are not a coincidence. God gives us ideas and passions to mold us into who He wants us to be and for us to put our faith in Him. And while all of your ideas won't be THE million dollar idea, it will certainly be a learning experience that you will need for what's next. Know that God is intentional and everything that happens in your life is not by accident.

My goal is to make you get off of the endless cycle we tend to go through every time we get a new idea. You know, you get the big burst of excitement to start a new project, write down all of the details, and maybe even buy the supplies, then dump it before the idea sees the light of day because something in your mind told you it was not good enough.

I'd spend hours curled up on the couch reading "how-to" books, watching YouTube videos, and stalking Google for hours, but never implementing anything I learned. And I could not figure out for the life of me why I couldn't just get up and start. Eventually, I would let that idea phase out and be on to the next.

But there is hope. Building my own platform and

trusting God to use my gifts has given me new life. And as cheesy as this may sound, I finally have a voice and I'm making a difference in this world.

What To Expect

This book is not about being perfect or sharing my "perfect" story because I still battle with these mental barriers, too. This book is about making an effort to step out on faith and do your part to begin living an intentional life. This book is for you. And while I may not know your exact story, I have written this for you whether you are in the midst of starting an online business or if you are just unsure of what's next in your life. Here is what you can expect throughout these pages:

For starters, this book is broken up into four different sections:

Change

Purpose

Mental Obstacles

Faith & Action

I will also be sharing my journey from being hopelessly lost and feeling insecure around people who seemed to have it all together to taking a leap of faith and building my online business, all while still struggling with many of those mental barriers that tend to keep us stagnant.

To get the most out of this book, I encourage you to read it straight through the first time around and then use it as a guide to reference back on whenever any mental blocks pop back up down the line.

Throughout the pages I'll be sharing some of my favorite scriptures to support why you should begin living on purpose. You are here for a reason. With God's strength, you can tackle any and every obstacle that comes your way. Throughout this book you will be reminded that God wants you to do miraculous things with the gifts He has given you and that you can fully put your trust in His will.

And while I want this book to encourage you and light a fire under your bottom make some major changes, I also want you to take some serious action. At the end of each chapter, you will be provided with action steps to take in order to actually implement what you have retained in relation to your own life. You will also find affirmations to hold close and speak daily. These action steps may make you feel uncomfortable, but the discomfort is worth digging into.

Want a deeper connection?

I encourage you to journal any thoughts or emotions as you go through each chapter.

My hope and prayer is that this book helps you uncover what you were placed on this Earth to do and also helps you take big steps forward despite what you may feel is holding you back. I pray that you truly get a better understanding of what it means to live rather than exist and the uncovered meaning gives you the guts to continue making big changes in your life even after the book is over.

Again, there is no such thing as being perfect or even being 100% fearless. However, if you put in the work and commit yourself to changing you will not only see a positive shift in your life but the way you do business as well.

ACTION STEP: (Fill in the blank) I Choose to Live because _____.

AFFIRMATION: I choose to live because everything I desire is one step outside of my comfort zone.

Section I:
The Will To Change

Chapter 1:
What Does It Look Like To Live?

"To live is the rarest thing in the world. Most people exist, that is all" - Oscar Wilde

Before we move on to tackling what's holding you back, you're probably wondering what *"living over existing"* really means?

Does the thought of living mean leaping from the top of a mountain only to be secured by a rope as thin as a rubber band? Or does living mean quitting your cushy career to pursue your lifelong dream of backpacking through Europe? There is no one size fits all image to what it looks like to truly live, but what living doesn't look like is giving up on your dreams or what you feel called to do simply because what it takes to get there seems hard, it's scary or because someone close to you says it's impossible.

A woman who solely focuses on what seems possible, rarely lives a fulfilled life.

A few months before I was set to graduate from college, like many upcoming new grads who graduated during the recession I found myself jobless, hopeless and about to be in a lot of debt from the education I

had just received. I had high hopes of landing a career in public relations that I had equally studied and interned my butt off for and envisioned myself working in a modern office downtown with white walls and huge windows that pushed through the perfect amount of sunlight from every angle. My coworkers would show up relaxed in jeans and cool tshirts and we would discuss attending fabulous client events every morning over fancy brewed coffee.

I had it all planned out.

Or at least I thought.

It seemed like every time I'd apply for a new position, I'd immediately receive a rejection letter. Every few days my inbox would be filled with rejection after rejection and I would stress myself out trying to figure out why I wasn't at least getting a chance to interview. Either I was under qualified, over experienced or never heard back even after several follow-up attempts. The rejection was starting to take its toll on me both mentally and physically as I felt like I was in a race to land a job before I walked across the stage.

I grew up in a small town, and like many, I believed that college was my only way out. After getting a taste of "the big city," I knew returning home wasn't going to be an option. I was in "sink or swim" mode and felt like I really had no other choice but to figure it out.

The Grand Idea

I had never really considered it before, but out of frustration and desperation I thought about possibly starting my own business. Going into business for myself would be a stretch considering that I would have no clue

what I was doing, but if no one was going to give me an opportunity then why not try and create my own? I figured at the least, if I started my own business then I would be able to support myself until something else came along. And the fact that I could be my own boss and do something everyday that I enjoyed was just the icing on the cake.

At the time I was really big into the local music scene and had dabbled in music journalism and blogging throughout college. There were a ton of online platforms that showcased mid to large artists but not many that catered to the local artist who were just looking to get their name out there. So I came up with the idea of starting an online magazine dedicated to allowing local artist to share their story and their craft. A space where readers could discover new artists who weren't typically hyped up in mainstream media but equally as talented.

The light bulb went off in my head and the entire idea just felt right. It gave me something more to look forward to outside of waiting to hear back from potential employers and a little hope that I wouldn't become a helpless adult.

I felt alive.

I was so obsessed with creating this new venture that I would spend what little money I had left after paying rent on purchasing business books and magazines. And I'd spend hours re-connecting to my neighbor's wi-fi so that I could find every website and YouTube video imaginable that would teach me how to build a website from scratch and for free.

Looking back, I see that even at the age of 22 I still had a bit of that childlike faith inside of me. I was excited and ready to bring this vision of mine to life with no doubt that

it would be anything less than extraordinary. And I knew that without a shadow of a doubt, that this idea would work and that somehow God would turn this magazine into what I would ultimately build my career around. Much like a child who has no doubt that their parents are there to take care of them, I knew that I was covered.

That's the type of faith God wants us to have in Him. He wants us to truly believe that He has us covered and that we are capable of doing the impossible with His guidance. Steven Furtick calls this having "audacious faith." The type of faith that stretches what God can do in our lives by asking for what the world would deem as impossible.

The only problem was, the doubts I had developed since becoming an adult were raging in me as well. The more I researched, the more I realized how much I didn't know and how much work it was going to take for me to get this concept off the ground. For one, I had no clue how to begin creating editorial style content. I was a broke, soon to be college graduate, so I definitely didn't have the money to hire a photographer nor did I have the money to purchase my own camera (remember I was faithfully praying that my neighbors wouldn't lock their wi-fi). The more I pushed to try and make this idea happen the more I allowed those fearful thoughts to creep in.

"You'll never be as good as them."

"These people have teams, you can't do all of this by yourself."

"You should be focusing on finding a job instead of creating this magazine."

What Does It Look Like To Live?

"You don't even know enough about music to keep this going."

The more I focused on what I didn't know, the same fears and doubts began to drown out the excitement I had for this new idea. And instead of spending my time trying to figure out what I wasn't experienced in, I wasted time coming up with every excuse in the book as to why I couldn't move forward.

I'd tell myself that I needed to wait on a mentor or that I needed to wait until I had more money. That I needed to wait until I could get a team of writers or at least until I had more knowledge of the local music scene. The research became less frequent and more and more every day the entire idea felt less possible to turn into reality. So I let it go. I ended up making myself believe that I gave up because I really wanted to focus on getting a "real job" but what I really did was allow fear to win.

Alisha 0, Fear 1.

That's what it looks like to exist. Existing is nothing more than allowing your fear or your insecurities to control you instead of you having control over the fear. Existing is making excuses instead of making a way and using the resources that you have.

But you have a choice.

If I were truly ready to make that magazine happen, then my story would have played out a lot different. Instead of looking at fear as a physical brick wall that was standing in my way, I would have looked at it as a wall that I could easily break through. If I was truly ready to live in that moment I would have continued to do the research, I would have

reached out for help and instead of waiting for everything to be perfect I would have taken the leap and adjusted my sails on the way down.

Take a moment to think about what has stopped you right as you were about to take the leap into moving forward on a new idea. Go back to that exact moment and think about what was it that held you back. For me, it was clearly fear mixed with self-doubt but for you it may have been the negative opinion of someone close to you. Or maybe you saw another business owner with the same idea and an even bigger audience and you allowed comparison to make you pause and hesitate. Maybe it was the fact that you couldn't move around making up excuses instead of thinking of solutions.

Whatever the case may be, your business will never grow beyond being just an idea if you can't get clear on what is holding you back. Figuring out the cause of a lot of your insecurities and fears early on prevents you from making the same mistakes over and over again. And being clear on your weaknesses will help you to be prepared for the next time you decide to act on a new idea. Instead of being blindsided by the same thoughts and emotions, you'll be able to face them head on and realize that what you're feeling is only trying to hold you back.

You were designed to live a prosperous and flourishing life, why not own it?

I wish I could say that this moment is what changed it all. That I realized how my choices were affecting my life and that I promised myself that I would never allow fear or any type of insecurities to hold me back again. And I wish that I could tell you that my next big idea became the

business that I run today. But even after that moment I was still merely existing. Because what I needed wasn't just a cure to all of my fears or for someone I cared about to tell me to keep going. What I needed was the will and the desire to change my life and mindset for the better.

ACTION STEP:

a) What does living look like to you? Does it mean taking a chance on your new business idea? Does it mean possibly going part-time in your career so that you'll have more time to work on your business?

b) What is currently holding you back from truly living?

AFFIRMATION: I am motivated to pursue what I was created to do despite of what holds me back.

Chapter 2:
Are You Willing To Change?

"Progress is impossible without change, and those who cannot change their minds cannot change anything"
- George Bernard Shaw

I sat at my dining room table as I rehearsed under my voice over & over what I was going to say. I knew the question I had to ask but I wasn't 100% sure what the outcome would be. My pride was hurt, I was embarrassed and couldn't believe that after four years of hard work this was going to be my final outcome.

You would think that after giving up on my magazine idea and realizing that I honestly had no other options, that I would have put my foot down and worked my butt off, but life doesn't write perfect stories. As it were coming to the end of my lease and my roommates were all going their separate ways, I had to face the fact that my only resort was to do what I promised I would never allow to happen.

I picked up the phone, dialed the number and with a trembling voice from trying to hold back my tears I asked "Mama, can I come back home?". Just to show you how quickly the enemy will make you feel as if you have been defeated and that you have no other options, right when I figured I would get a lecture, she replied "Oh, I just assumed

you were doing that anyway. Of course you can!".

As upset as I was, I also felt a bit of relief. Having to go back to my hometown after bragging about leaving and never going back hurt, but I knew I needed this break from adulthood to figure out what was next. A couple of months after having that conversation, I graduated and found myself back under my mother's roof, with her rules and living in the same tiny bedroom I had grown up in.

That's when life got real.

Little did I know that God was slowly breaking me down. He needed me to be ready and willing to change so that I could truly begin living on purpose. I had become complacent and comfortable with merely existing and not doing any more than what was required of me. While I wanted more, I wasn't ready to make the necessary changes to get to where I wanted to be.

Change is the only guarantee we have in life but it is often feared because it puts us in a position to be uncomfortable. Change is unfamiliar and the outcome is often uncertain, which makes the risk feel even greater.

While I wanted to do more with my life and wanted to get out of the situation I was in, the thought of stepping out and actually making progress towards change terrified me. Moving home gave me a bit of relief, so why would I mess that up? I went from being a broke, often hungry college student who was struggling to make ends meet to having the weight of paying any major bills taken off of me in a matter of one move.

I didn't like where I was but letting go of that comfort and taking a dive into the unknown wasn't worth the risk.

At least that was what I subconsciously told myself. On the surface I kept saying I wanted to change.

Again, I was existing.

Before we can dig into battling your fears, pushing past self doubt or any other obstacle, it is important for you to know that not being willing to change is just as worse as any negative thought that has ever crossed your mind. If fear is what's stopping you from starting that business then having the will to change is what is stopping you from pushing past that fear.

Just because you say that you want to change doesn't mean that you're ready to put in the necessary effort to make the change happen. It is possible for you to be so comfortable and complacent that you believe that by simply saying, *"I want to change"* that a transformation in your life will take place. But change is the result of action. Even if that means taking small steps towards your end goal.

If you continue to say that you want to finally pursue your idea and turn it into a business, then what steps are you taking to make that happen? Have you purchased the domain name? Have you taken the time to outline your project? Have you begun to implement any of the strategies that you have spent hours researching? What personal changes have you made in order to turn your idea into reality? Do you need to change your mindset so that you truly believe that this business is possible? Or do you need to change the people you hang around so that you're more motivated to get to work?

God had bigger plans for me, as He has the same for you. Which means putting us in situations that require us to take big, bold leaps of faith. The same faith that requires

us to put our trust in him instead of solely in ourselves. If I wasn't going to willingly surrender to Him, He was going to continue to make me uncomfortable until I let go. And the same goes for you. In order for us to walk into our calling, God often needs us to be willing to temporarily give up our comfort.

That is the hardest part with trusting God with our journey. Trusting that even when it doesn't feel good or line up with what we desire, we have to remember that He's only doing what's best for us, even if it initially makes us feel uncomfortable. And also remembering that what He wants for us is the only way. Even if that means breaking us down to the core in order for us to get on board with his plans.

You have the God-given power to speak what you desire into existence but you're also required to meet God halfway with your actions. It's like praying non-stop for God to bless you with a new job but you never take the time to complete any job applications. I fully believe that God can work miracles, but how unlikely is it that a job just lands in your lap one afternoon while you're watching Netflix?

Before sitting down to write this book I kept praying and asking God to shift my brand and to make me a best selling author. I would write that goal out in my journal every single morning, I had a big colorful vision board in front of my desk so that it was the first thing I saw when I looked up and would I pray constantly. But every time I would sit down to write, I would get distracted and put off writing for another day. But sure enough, every morning I was back praying and asking God to make this book successful.

It wasn't until one morning that God hit me with a harsh reality check about what I was hoping for. I was writing out

my vision and goals for this book, the same as I had been doing for months, and I heard Him clearly say, "Then why are you not writing?". How crazy was I that I prayed and hoped for God to make this book successful when I was dragging my feet to meet him halfway? Needless to say it was the smack in the face that I needed to begin this journey.

In your case, taking action may mean completing that website, taking that class or even consistently promoting your idea. You have to give God something to work with. He isn't some type of genie who just magically provides us with everything that we desire after one prayer. Stop expecting Him to take your dreams to the next level if you're not willing to meet him halfway.

Jeremiah 29:11 (NIV) reads, *"For I know the plans I have for you"*, *"Plans to prosper you and not harm you, plans to give you hope and a future."*. That scripture is one of the many promises from God to you and I. It offers assurance and gives us hope that we can trust that better is yet to come. That promise doesn't mean that our journey will be perfect or that every single step we take towards change will be divinely set by him. It means that we can again find hope in knowing that He has everything under control, even if our situation doesn't look or feel good at the moment.

Are You Ready To Change?

There is a difference between wanting to change your life and actually deciding to do something about it. And it is up to you to decide if living your life is worth taking action now or later. If you feel like you still need some convincing, I've compiled a few clues that will help you decide if you're

truly ready to change.

You're tired of feeling directionless. Maybe you know deep down that the life you're currently living isn't what you truly desire. Or maybe you feel like you are supposed to be doing more but you can't quite put your finger on what that "more" is. And worst of all, you feel like everyone around you has it all figured out and living their life on purpose, yet you still feel like you're just existing. If this is you, then consider this as your sign to make the first move.

You picked up this book. Seriously, I'd say 9 times out of 10 you picked up this book because you knew that you needed to make a few mindshift changes before really pursuing your big business ideas. More than likely it isn't a coincidence that this book is in your hands right now. Embrace that feeling and begin putting in the work to make your dreams happen. This book is filled with action steps that you can begin taking immediately.

You've received signs from all over tell you to go for it. When God wants to speak to us His message isn't always in a big bold voice coming down from the heavens like the movies portray. Often God uses people, places and certain situations to make what He wants us to do next known.

One of my many signs came from my morning devotionals and the quiet time I spent with Him each day. The passage for that day would just so happen to be geared towards taking the leap of faith or on trusting God with your vision. Or I would go to church and the pastor would introduce a new series on faith. I would even turn on an episode of Shark Tank and the business owner would share

his story of leaving the job he hated to pursue his business full-time. Again, these are not coincidences. God often uses our surroundings to point us in the right direction when we're feeling lost.

You've hit your breaking point. Maybe you've gotten so far deep into your situation that you feel like your back is up against the wall. That whatever you are currently going through has gotten so bad that you have no other choice but to change.

Trust me, when you have hit your breaking point, you will know it. It is that moment when enough is enough and no matter what is at stake you're ready to give it all up just to be happy. I often compare it to being in a bad relationship. No matter how much your friends tell you that he's no good for you and that you should leave him, you still keep going back because you have "history".

It isn't until you catch him cheating for the 12th time that you finally say "enough is enough" and you decide to part ways. In that moment of hitting your breaking point you decide that you deserve better and all the history you have together goes out the window. The same thing will happen when you finally decide that your big idea is worth pursuing. Once you're fully ready to make the necessary changes, you'll hit a point where nothing can stop you from pursuing that idea with your whole heart.

A Little Hope

I wish that I could tell you that in that moment of complacency I took control over the situation I was in and began making big changes in my life. But change for me

didn't happen overnight and honestly if it were that easy this book would have never happened. Remember when I mentioned that giving up on my magazine idea wasn't the slap in the face that I needed to start living on purpose? Well it took hitting rock bottom for me to really decide that I was ready to change.

When I moved back home I took on random jobs to help support myself. None that offered me my glamourous office in a high rise building downtown, but one that helped me to eat and pay bills so that I wasn't 100% dependant on my mom. Each day felt like I was in the Groundhog Day movie. Wake up, go to work, come home, go to sleep, wake up and do it over and over again. Everyday that I had to wake up and go to work I felt like the little bit of hope that I had left was being sucked out of me.

I was unhappy and unfulfilled. And although I knew I was talented and had something of value to offer the world, I became complacent in the dead-in jobs I was chasing. They were easy, the money was guaranteed and they gave me a bit of stability after years of struggling financially through college.

Again, I was existing.

While I could have stepped out of my comfort zone and kept applying for careers that would actually allow me to use my talents or go back to my dream of starting the online magazine that I was once obsessed over, once again I found myself completely overwhelmed with fear.

Yet again I was allowing self-doubt to constantly remind me of how unqualified I was. How that more than ever I wouldn't amount to anything that I had planned because I had taken ten steps backwards by moving home.

Are You Willing To Change?

I didn't want to be in the position I was in but I also wasn't doing anything that would change the situation either.

Alisha 0, Fear 2.

In a pursuit to begin doing better, I landed a job in a call center that paid fairly decent. And by decent, I mean that I actually had a little money left over when payday came back around. The only issue with the job was that it made me miserable.

I'd spend eight hours everyday in a dark grey cubicle about the size of a large bathroom stall taking phone calls from people who were mostly terminally ill and needed help paying their medical bills. The building we were in had been converted from an old grocery store so there were no windows and smelled as if it were infested with mold. It was so draining that when I began accumulating vacation hours I would take random days off even when I didn't have plans just so I didn't have to go in.

During this time I began seeing a trend in jewelry online. Simple yet colorful beaded bracelets that were accented with different metal charms. I wanted a stack of them so bad but every online shop that sold them were crazy expensive. So one Saturday I decided that I would try to make my own. I went to the craft store, purchased about $10 in supplies and sat on my living room floor until I figured it out. I had always been pretty creative but actually being able to hold something that I had created (and created well I might add) was exhilarating.

I was excited about my new hobby and began wearing the bracelets whenever I would go out and also shared them all over my social media platforms. The more I shared, the more people kept asking me where they could be purchased.

It wasn't my initial idea to turn it into a business, honestly it was just a really cool creative outlet. But if people were willing to buy, I figured I really didn't have much to lose.

I was literally spending five days a week in a job that I hated so if taking this chance would bring me even an ounce of joy, I knew it was worth a shot.

I hit the ground running and researched everything I could on how to open an online shop much like I did when I got the idea to start the online magazine. But this time was different because I was bound and determined to actually see something change in my life. With the magazine I was stuck in the idea phase, and although I was doing the necessary research I never implemented anything I had learned. But with this online shop I made the decision to not only do my research but to also put in the work needed to bring the idea to life.

A few weeks later, my online shop Eclectic Star was born and I had gained that hopeful feeling back. Although I wasn't sure if the shop would ever be anything other than an expensive hobby, side hustle or my life's purpose at the time, opening that online shop gave me something to look forward to everyday instead of dreading to get out of bed. If for nothing else, that was all I needed to begin looking at my situation differently.

We'll get into uncovering your purpose soon but it's important to find what brings you joy in the midst of the storm. Even when God is trying to get us through to the other side of our mountain he always provides us with something that will continue to give us hope while we're fighting.

The Light Bulb Moment

One cold, rainy morning my alarm clock went off blaring obnoxiously in my ear. Still completely miserable and emotionally beaten down from the call center job I was working, I woke up with a heaviness in my chest. I was exhausted and wanted nothing more than to curl up back in bed. At the least, I would have loved to spend my day working on new items to add to the shop. The thought of having to get up, get dressed and drive in the cold rain to a place where I would spend eight hours getting cursed out by callers overwhelmed me as the heaviness in my chest got tighter.

I got up, sat on the edge of the bed and began crying my eyes out. My sister who was also up getting ready for work, walked into my room, saw that I was an emotional mess and just hugged me. I was so distraught that all I remember her saying was *"It's going to be ok Alisha."*

I knew I needed to change and you better believe that dreadful morning lit a fire in me that I had never felt before. I had taken the leap to starting the business but I still viewed it as just a hobby. But I knew that if I eventually wanted to cut ties with the job that drained me both physically and emotionally, I needed to switch my thinking to looking at my shop as an actual business.

That simple mindset shift is often what separates good businesses from great, highly successful brands. The shop was doing well but not well enough to sustain me, so I went back to researching everything I could about how to effectively market your products both online and off.

Again, the only guarantee in life is change. And it's up to you whether you will kickstart that change or not. You can

begin taking tiny small steps towards your goal or what feels good to you or you can stay in your situation and continue to make up excuses as to why your life isn't getting better.

I couldn't imagine never doing something purposeful with my life that would make me excited to show up every single day even at the age of 60. I couldn't bare to think of how much regret I would have to live with in my later years knowing that I never put forth any effort. It was like a light bulb had went off in my head and I suddenly realized what the missing link was.

Yes fear, self-doubt, comparison and a bunch of other emotions had been holding me back. But what had also hung me up was not being ready to change. I realized in that moment that what was holding me back was the fact that I wasn't ready to take that first step towards following a greater purpose because my comfort zone was safe.

Settling for safe rarely produces an extraordinary life.

I know what you're feeling right now. You may be a little anxious or a little worried that big steps could possibly lead to big failures. And I won't lie to you, failure could very well happen. But would you rather fail now, pick yourself back up and learn from those mistakes OR live with the regret of never trying. The regret of never giving your big business idea space to grow? I 100% understand exactly what you're feeling right now, but let me tell you something, God gave you that idea for a reason.

While your grand idea may not become your life's calling or that million dollar, Shark Tank worthy brand, it's a stepping stone for God to use you to get you closer to what he has called you to do. I mean this is the guy who died on the cross for you to be able to have opportunities like this,

don't you think you owe him just enough to try?

Do something that your 60 year old self will thank you for. And if you just so happen to be reading this and you are already in your 60s, know that it's never too late. Do something that your 90 year old self will thank you for.

One recurring theme you'll find throughout this book is that you're more than qualified. Qualified to change, qualified to take a leap of faith and qualified to pursue that idea that has been placed on your heart. In Joshua 1:9 (NIV) the Lord says to Joshua; *"Have I not commanded you? Be strong and courageous. Do not be afraid; do not be discouraged, for the Lord your God will be with you wherever you go."*

If you've been waiting for a sign, consider this it. God has given you instruction and has proved that He will be there with you every step of the way. So what are you waiting for?

My Breaking Point

After that morning, I continued to go to work but my attitude was different. I was ready to change but still somewhat playing it safe. I'd put together a plan of how to grow my business and set a date for when I would quit my job, only to go back to it and decide it wasn't realistic. I kept pushing back my "quit date" and made myself believe that I needed more time to get ready.

Little did I know that God was about to give me the ultimate push that I needed to leap into faith and his grace.

I had been taking calls all morning at work while scribbling jewelry ideas on a scrap piece of paper. This day was no different than any other so I wasn't expecting what

was about to happen. I answered a call like normal and was immediately greeted with a lovely woman (and I use the term "lovely" very loosely) who wanted to discuss her bill. As soon as I answered the phone she began screaming at me as if I personally placed the charges on her account and within minutes she had called me every obscene name in the book.

While deep down I knew I shouldn't have let her anger get to me, it did. My eyes began to swell with tears, my heart began to race and I felt like I was struggling to catch my breath. In an effort not to completely lose it in front of everyone, I hung up the phone and ran to the bathroom.

I lost it right there in the stall.

As I tried to regain sanity and catch my breath, I called my mom to explain to her what had just happened and how I couldn't handle the stress that the job caused me. My mother has always been my crutch when it comes to not knowing how to handle different situations or when to make a big adult decision, so hearing what she had to say made my next step easier. As she explained to me that I was a smart girl and that I would be ok no matter what I chose to do, I made the decision that I had to leave.

The next day, with no real solid plan I put in my two week notice and made the decision to see where God and my online shop would lead me. I had reached my breaking point and God used that as an opportunity for me to take the leap of faith that he was waiting on me to take. Your breaking point may not be as dramatic as mine or may not lead you to abruptly quitting your job. I mention all of this to say that in order to change, you have to actually want it and be willing to do whatever possible make it happen.

Are You Willing To Change?

"When we hit our lowest point, we are open to the greatest change." - Aang, The Last Airbender

This scripture is one that I have held onto since I was a struggling college student searching for answers;

"No temptation has overtaken you except what is common to mankind. And God is faithful; he will not let you be tempted beyond what you can bear. But when you are tempted, he will also provide a way out so that you can endure it." - 1 Corinthians 10:13 (NIV).

Your breaking point will be one of the hardest situations that you will ever have to go through and will truly test your strength. But have faith in knowing that you will never be given more than what you are equipped to handle. If you've hit rock bottom, find peace in knowing that your breaking point is the first step to reaching your breakthrough.

Also know that you do not have to wait until you've hit your breaking point to start making changes in your life. That is usually just what it takes for most people to finally wake up and make a choice.

Start now.

ACTION STEP: How are you being broken down? In what areas of your life do you need to surrender to change? Take some time to journal about the reasons you are ready to make a change. What whispers or signs have you seen that's telling you it is time for you to make a move?

AFFIRMATION: I believe that change is good and will produce positive results in my life.

SECTION II:
Your Purpose

Chapter 3:
Lack of Purpose

"Efforts and courage are not enough without purpose and direction." – John F. Kennedy

I mentioned before that I was not sure if making jewelry was my calling, but I knew that it was a step in the right direction. To be honest, figuring out my purpose was the last thing on my mind. I was in a season of sink or swim, so my focus was more on what would make me money and less on what I was being called to do.

Since I had abruptly quit my job, I decided that I needed an outlet, a space where I could record my thoughts and document my journey of becoming a real business owner. So I turned to writing. I wasn't born into a family of entrepreneurs nor was there anyone close to me who was running their own business, so navigating my way through building my own brand started to feel lonely.

Writing has always been an outlet that I have used when I felt like I couldn't properly verbalize my emotions. So when I felt like I didn't have anyone to turn to, I turned to what I knew best. I started my blog strictly as an online journal to rant about my journey as a new business owner. I wrote on

my successes and how my jewelry was featured on different blogs and websites. I wrote on the disappointments and how I was afraid that I wouldn't make enough and how no matter what I did to try and grow the business, something just didn't feel right.

The more I wrote, the more I fell in love with the process. There was something therapeutic about pouring my heart out into the page that made me feel relieved. And just like when I first started making jewelry, writing quickly became all I wanted to spend my time doing. Not to mention through sharing my journey, I began building a community and small following around the blog and started receiving tons of questions and emails from other women who were wanting to know how they could take the leap into entrepreneurship.

Suddenly, I began to notice a shift.

After a couple of years of learning the ins and outs of building an online business, making jewelry began to feel like a chore. I'd sit down to create something new and would all of a sudden feel frustrated with the process. My ideas were not as good as they once were and all I could think about was getting back to posting on my blog. I knew deep down that I was in midst of making another shift but just like before, I was terrified.

The online shop I built, although wasn't perfect and definitely wasn't making me millions of dollars, got me out of that job that I hated. It gave me a bigger purpose and something to look forward to everyday and for a few years leading up to this point, it was all I had imagined doing with my life. So who was I to drop what I had risked so much to go after?

But I couldn't deny how writing made me feel. I imagine it's the same feeling of falling in love with two men and having to weigh the odds of who to spend the rest of your life with. Writing took me back to a time when I was the happiest, it made me remember all the times as a child when I would spend hours imagining up characters and writing short stories. My gut was telling me to take another leap, but my mind constantly reminded me that I had so much to lose. Eventually, it came down to having to make another choice...purpose or comfort.

Your purpose is the why behind the reason you exist. It is the divine gift that God has given you to ultimately serve others and to please Him. Digging deeper into gaining clarity and uncovering your purpose is the basics of living. It means you're not going throughout life aimlessly and that you have something worth waking up for every morning. But there is a difference between what you've been purposed to do and what is only meant for a season.

God created us with a special, unique plan for our lives. Often throughout our life we come to a crossroad where what we thought was our calling turns out to only be a chapter leading up to our purpose. In that moment we are forced to either turn the page and ask God for his guidance or continue to stay stagnant in a space where we know we are no longer needed.

What holds us back from diving head first into turning that idea into a business is often lack of direction. So what happens when we've spent so much time working towards something that actually isn't what God ultimately wants for us?

Your own desires, passions, or the opinions of what

other people think you should be doing with your life could currently be leading you down the path of pursuing the wrong purpose. I noticed through running my online shop that if we are doing what is opposite of God's will, we will constantly feel dissatisfied. And while you may be happy in the moment, you'll ultimately feel that something is missing.

Let me also mention that not all great businesses are built around purpose. Some are built around a need that is not being filled in an industry or a pain point that a specific audience is experiencing, but that is a different conversation for a different book. The purpose of Living Over Existing is to help you dig deeper into your purpose. Because no matter the amount of money you make or if this idea really takes off as a successful business, your purpose is what you were created to fulfill. Therefore, it is worth discovering.

You were not meant to be complacent or stagnant. By not fulfilling your purpose, you are doing those who God created you to help a disservice. Yes, your purpose is about you, but it is more about how you will serve others. I'm writing this book because I know deep down I'm a writer but I'm also writing this book for you because I know where you are and I know how avoiding your calling and ignoring your ideas will affect your life in the long run.

You can't just go through the motions, there is something in you that you need to live for; an idea that you're supposed to give new life to. The issue with coming into and accepting your purpose is that often we're either too stubborn to accept the gift we have been given, we think our gift is insignificant, or we're unaware of what we were placed on this Earth to do. Especially, when it doesn't line

up with what we thought was our purpose.

When I decided to close my online shop I felt guilt, I felt shame and I honestly felt crazy. But I quickly realized that running my online shop wasn't a waste of time, that it was actually a very important piece to my story. More importantly, I realized that every heartache and season of confusion that I had experienced, happened for a reason.

Everything happens for a reason.

Whether that reason be small or impactful, what has happened in your life needed to take place in order for you to reach your potential. If it wasn't for my crazy idea of making jewelry, I wouldn't have had the courage to step out of my comfort zone. I would not have been opened up to a world of new possibilities, nor would I be sitting here writing this book.

If you're reading this and you're unsure if that idea you have is truly your calling or if the business that you've been working so hard on is aligned with your purpose, then don't let it frazzle you. We are going to dig deeper into uncovering your purpose and what God says about what we are put on this Earth to do.

ACTION STEP: Think about all of the different seasons in your life that has led up to where you are today. What do you feel like you are being called to do next?

AFFIRMATION: God has called me to do incredible work. Everyday he is revealing to me what I am called to do.

Chapter 4:
Uncovering Your Purpose

"It is time for us to find the thing we were created to do, the people we were meant to affect, and the power that comes from alignment with purpose." - T.D Jakes

You were meant for something greater...I cannot say this enough.

If you're currently feeling lost or not sure what is next for you, then this portion of the book will be a great place for you to begin gaining clarity.

You would think figuring out our purpose would be as simple as taking what you genuinely enjoy doing and figuring out how to use it to serve others, but uncovering your purpose typically isn't that easy. Instead of looking to God for the answer to the question, *"What am I here for?"*, we try to create our own paths and completely ignore what He is pushing us to do.

As we get older we follow what our parents desire for us to be, what society tells us is "successful" or what we see is working for everyone else. And instead of digging deep into our unique calling, we end up on an endless cycle of constantly feeling like something is missing.

I spent the majority of my life trying to be in control

of my own life and how I wanted it to look. Stressing over all the details and becoming anxious in the unknown, meanwhile I imagine God sitting there shaking his head just waiting for me to ask for his guidance and put Him in control. I felt like I was running out of time while God knew that I wasn't ready.

If you are unsure of what your purpose may be or if you want to be sure that you are on the right path, these next few exercises will help you to get clear on what you desire and also help you determine if it aligns with what you are already predestined to do.

Your Inner Child

Every decision I have made over the past few years has been based on what I said I would do when I "grew up." When I decided to take my blog seriously and expand it into an actual business, I realized that my love for writing didn't just pop up out of thin air. It was something that I had loved since childhood.

I was the child who was more interested in spending her allowance on the new Lisa Frank notebook and pen set than I was with Barbie. As an introvert from birth, I found peace in being able to get my thoughts and emotions out onto paper and become consumed with the characters I imagined.

The earliest piece of confirmation that I could become a writer was from my 3rd grade teacher, Mrs. Williams. She was a short, stocky woman with curly hair and big glasses who always smelled of spearmint gum. I remember before leaving school for the summer, she pulled me to the side and smiled while telling me how I excelled on the writing

portion of my end of school testing. She looked me in the eye and said "Please don't stop writing." I took that idea and ran with it while spending my summer begging my mom to buy me notebooks so that I could continue to write.

As I got older, I held onto that memory and never let go of my love for writing. I always excelled in and adored English class, was one of the few students to sign up for the creative writing class and was on my high school's newspaper. Writing was and has always been my way of escaping and feeling like I was being heard. Little did I know back then that God was giving me a glimpse into what I was ultimately being called to do. What seemed like a hobby back then, is now a major part of who I truly feel like I was created to be.

Even as I entered into college, I knew that I would be a writer of some sort. That was until I started listening more to the world around me and less of what my gut was telling me to do. The more I began telling people that I wanted to become a writer the less positive the reactions were, unlike when I was an eager 10 year old. I was told that I would never make any money as a writer, that print was dead and that I should choose a degree that would allow me to achieve a stable career. And slowly that inner child within me that had so much spark and passion slowly began to fade away the more I allowed the outside world to get into my head.

See that's the only issue with your purpose, passion and your dreams. God gave them to you, and only you. The only way others can truly understand, is if God opens their eyes to see them the way that you do. Instead of exploring more into what being a writer would lead me to, I allowed outside sources and my own fears to knock me off track. And it took me until I was around 26 years old to really dig deep

into what God was calling me to do.

Thankfully, the online platform that I have built, has allowed me to pursue my purpose and use my words to help other women feel like they have a voice and provide them with actionable steps on how they can begin living on purpose.

I dare you to ask yourself, *"What did I love most when I was a child?"* In those moments, what made you the happiest? Aside from wanting to be a princess or Power Ranger, what did you see yourself doing when you "grew up"?

Uncover Your Sweet Spot

Uncovering your sweet spot is a more technical exercise that I use to guide my clients through figuring out what they should focus their brand around. While it may not land them exactly on their life's calling, it does help them to gain clarity and eliminate some of the noise that is keeping them confused or stagnant. Whether you are dead set on starting a business today or you want help figuring out what you may be called to do, this exercise has helped dozens of women gain clarity and get focused.

I call it your "sweet spot" because it is the common denominator of what you are skilled at, what you're passionate about and what you're interested in. (refer to the diagram on page 55.)

To take yourself through the exercise, take out a pen and paper and take some time answering the following three questions:

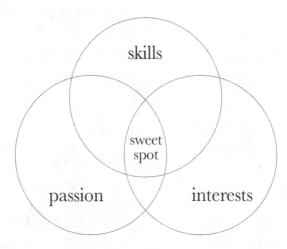

1. **What am I skilled at?** These are things that you are naturally good at. What are the topics that people constantly come to you for advice on? What can you do with ease?

2. **What am I interested in?** These are the ideas that you wish you knew more about or wish that you had more time to pursue.

3. **What am I passionate about?** What would you do for the rest of your life even if you weren't getting paid for it? A lot of times we claim to love something until money is no longer a factor. Getting paid to pursue your purpose isn't always a guarantee, so what would you continue to build your life around even if you were not being compensated for it?

Now take a look at the answers you wrote down for each question. Are there any common answers among the three? Is there a particular theme that really stands out to you? If so, then that's where you should focus your energy. If you are feeling good about what you came up with, the next step

is to begin praying and asking God if this particular focus aligns with the plan that he has already created for your life.

For an example of the sweet spot exercise, head over to http://bit.ly/ssexercise

Ask For Guidance

I promised myself when I began writing this book that I wouldn't make you feel as if you NEEDED to take any of these action steps in order to move past what is holding you back. There are so many different tips, strategies and guru's telling you what to do online and I didn't want to overwhelm you unless you felt compelled to apply my suggestions to your life. But this particular exercise is one that I feel is a non-negotiable.

Before I decided to close own my shop to fully focus on blogging and helping other women build their business, I prayed. At that time I didn't feel as if my relationship with God was where it needed to be but something in me kept telling me not to make that big decision until I had prayed about it. The more I prayed, the less anxious I became, the more doors opened up for me to expand my blog and the more clarity I had as to the decision I needed to make.

Prayer, for me, made the decision of closing my online shop easier. And I didn't walk away from it with any guilt or worry that I was making the wrong choice. Prayer provides peace in a time of uncertainty. And if there is ever a moment when you feel unsure, I suggest taking a moment to get still and pray.

God said it plain as day in Jeremiah 1:5 (NIV), *"Before I formed you in the womb I knew you, before you were*

born I set you apart; I appointed you as a prophet to the nations."

While we're out searching high and low looking for a sign, why do we hesitate to go straight to the One who created us? The One who had our entire life planned out before we took our first breath? Out of all of these exercises that I have given you to help you gain clarity, your true purpose is only going to come from God revealing his plans to you.

Give your gifts to Him and have faith that He will use them, not only for you to serve others but that he'll also use them to help you build a brand that supports you and the people you love. Sincerely ask him to reveal the plans he has for you. Ask him how you can begin to use your gifts to serve others and to prepare you for what's to come. Whether that be physically, mentally or spiritually.

Psalms 32:8 (NIV) says, *"I will instruct you and teach you in the way you should go; I will counsel you with my loving eye on you."*

Instead of continuing to be unsure or confused, ask God what your next step should be. He already has your life planned out, more than often He's just waiting for you to hop on board.

While I wish that I could tell you that if you pray today that you'll wake up tomorrow knowing exactly what your God-given purpose is, that isn't always how God works. Prayer isn't magic nor is it a guarantee that we will never suffer. As I've mentioned before, I've learned from experience that the big sign we are seeking won't come down from the heavens on a billboard with bright flashing lights. And that often our sign will come from our surroundings; A

passage in a book, listening to someone else's story or even a dream.

Practice patience and wait for God's timing. I get it, we currently live in a world that celebrates instant gratification. So waiting for God to give us the answers to our prayers can become exhausting when it doesn't happen within a matter of moments or days. But just know that His timing is perfect and there is a lot to learn in the midst of waiting.

If you're nervous about praying or have never prayed before, know that your prayers don't have to be perfect, nor do they have to be grand or loud. God already knows your heart, He just wants that one-on-one time with you.

I have made it a habit of writing down my prayers every morning. I am more in tune with my thoughts and emotions when I'm writing so it is only right for me to involve God in that process. Find some quiet time to yourself and hold a conversation with him. I promise He is listening.

ACTION STEP: Spend some time going through the exercises mentioned above but don't rush it! Pray and ask yourself what you are feeling most drawn to.

AFFIRMATION: I am in alignment with my God given purpose.

Chapter 5:
Pursuing Your Purpose Despite Of

"Don't be distracted by criticism. Remember – the only taste of success some people have is when they take a bite out of you."
- Zig Ziglar

"I *don't think this is a good idea. I mean, you don't want to overwhelm yourself, keep it as a hobby for now."*

This is what an ex-boyfriend told me right before I hit "live" on my online shop. I had confided in him about this idea that I was excited to move forward on and was abruptly smacked in the face with his doubts and criticism.

As if I didn't have my own to deal with.

I looked at him in total disbelief and couldn't believe what had just come out of his mouth. Struggling to find the words to justify my reasoning behind wanting to take this leap, I couldn't help but to feel betrayed as if I had just caught him cheating with another woman. Why wouldn't someone who claimed to care about me want to support something that I had worked hard to create?

As I sat there stunned, I could tell that he saw the

disappointment on my face. But instead of trying to rectify the situation and back me up, he changed the subject. Even though I couldn't figure out the correct response, I knew in my head that I was done. As you already know, I moved forward with opening my online shop and needless to say, that relationship ended shortly afterwards.

Up until this point, I have allowed the opinions and thoughts of other people to shape my life instead of going after what I truly wanted.

"Don't major in journalism, you know you'll never get a real job with that degree."

"You shouldn't pursue that idea, you know it will be too much work for you."

But in that moment, after I had already overcome my own fears and made up in my mind that I was going to take the leap, I refused to allow what someone else had to say stop me from going after the business I wanted.

Many of us get held up by this, especially while in the idea phase. Even after we know what we have been called to do, we still hesitate and wait around for someone else's approval. But you don't need permission to begin living on purpose. The only person you need to move for is yourself.

Not everyone is going to be on board with your ideas, your purpose or what you feel passionate about. But one scripture to keep in mind when you begin to like no one is agreeing with your decisions is Romans 8:31 (NIV), *"If God is for you, who can be against you?"*.

While not much will take away the pain of someone close to you not agreeing with the choices you make, you have to remember that it isn't their purpose to begin with.

You'll exhaust yourself trying to win everyone's approval when Gods is the only one that matters.

The purpose you have over your life was given to you and only you, so no matter how hurtful or confusing it may feel, it's not meant for everyone to understand, accept or even support. When we allow criticism to hold us back from walking in our calling, we are doing a disservice to those who need us. Remember, your purpose isn't about you, it is about the people you are being led to influence, impact and serve. A lot of times we expect people to rally behind us and all of the grand ideas we have for our life, but you have to remember that not everyone has opened themselves up to uncovering their purpose the way you have.

When we receive criticism or doubt from those close to us, it's typically because they are projecting their own fears on us. They often can't fathom taking big leaps of faith and can't imagine doing anything outside of their comfort zone so they respond to our dreams and good news the only way they know how, out of fear.

The best way to begin moving forward is to simply ignore those whose faith isn't on the same level as yours and never take it personally. Nine times out of ten, it is not about you and your purpose, it is about you shining light on the fact that they have not yet decided to pursue their own.

Remember, It's ok to love people from a distance.

Ask God for strength to continue moving forward when you're faced with these situations. And yes, I understand this journey can be very lonely at times and sometimes you'll wish that you had someone rooting for you. But there is a bright side to all of this. Throughout your journey you'll find people who see the beauty in your calling and who will

stand by you every step of the way. Appreciate those people and keep them close.

ACTION STEP: Even if you have yet to experience this type of criticism, begin praying that you receive strength to continue moving forward when it does happen.

AFFIRMATION: I will not allow the opinions or fears of others to stop me from pursuing my purpose.

SECTION III:

The Mental Barriers

Chapter Six:
Fear Will Cripple You

"Every time your fear is invited up, every time you recognize it and smile at it, your fear will lose some of its strength."
- Thich Nhat Hanh

Ever since I can remember, fear has controlled my life in some capacity. I have gone through phases of being afraid of failure, being afraid of what other people would think, and yes, even the fear of success.

I was raised to use fear as a way to stay out of trouble and as a safety tactic. I was taught to be observant and to not make any decisions until I was certain and to always ask myself "what if" if for any reason I was unsure. While my upbringing kept me from doing anything that would land me in jail or being kidnapped, I didn't realize how much of an effect it had on me until my adult years.

Fear has held me back from speaking up for myself in horrible relationships; instead I just took what was handed to me. I clung to fear and used it as an excuse as to why I couldn't take the next step on any of the ideas or opportunities that I wanted in life. And I allowed fear to turn me into a control freak, which made me rely more on

myself to figure out life than I did on God.

The moment I decided to take my blog seriously and turn it into an actual business is when I realized just how much fear had taken over my life.

I had began coaching women one-on-one and helping them to figure out how to turn their ideas into an online business. Just like when I started the online shop, I felt good about the direction I was going in and felt like I was really helping these women change their lives. After closing down my online shop, I told myself that in order for this new venture to work, I would need to take chances and push past any of the doubts that I had. I went into this big change excited for what was to come and I knew deep down that I was onto something that would completely change my life for the better.

However, as I dug deeper into the transition, those fearful thoughts began to creep back in. Instead of jumping in, taking charge and creating my own space in this industry, I hesitated and played it safe. What's crazy about the situation, was that I knew that I was just letting fear hold me back. I had spent years going through the exact same process, so I could spot the symptoms early on. But I could not figure out why I was still holding myself back. Everyday was a constant battle between wanting to move forward and wanting to make myself smaller out of fear.

Although I was gaining a decent amount of new clients I wasn't making the money that I needed. But instead of scaling up and charging more for my services and the products that I sold, I hesitated out of fear that it would turn people off. I hesitated to share my expertise and what I had learned from years of running an online shop because I

didn't want people to think that I was a know-it-all. I made up excuses as to why I couldn't attend different networking events or agree to potential collaborations out of fear that I wouldn't be able to handle it.

I was existing.

Fear made me downplay my purpose. Fear made me look at the gifts that I had been given as if they were insignificant and too small to fully invest all of my potential and energy into. I truly believe that nothing upsets God more than us treating the gifts he has given us as if they are insignificant. Who are we to completely ignore or overlook what He created us to do? Who are we to feel that our gifts and talents can only be used to live a mediocre life?

That is what I couldn't wrap my head around back then. I was so afraid of taking the leap instead of looking towards the end goal that God was trying to lead me to. He never said the journey would be easy or perfect, but what he can assure is that everything that He has promised us will be worth it.

So what exactly is fear? According to Psychology Today, *"fear is an emotional response by a perceived threat."* PERCEIVED. Meaning, something that we have made to be a an issue that has not happened or probably will never happen.

If the love of money is the root of all evil, then I'm positive that fear comes in at a close second. Not only does fear create internal limiting beliefs but it is also what triggers comparison, anxiety and self-doubt. All of which we will dig into a little later. One mindset change I have had to make over the past few years and what I also constantly tell my clients is that fear is only an emotion and that we

should react to it as such. What do you do when you're angry? Eventually you calm yourself down and you move past it. What do you do when you feel sadness? Eventually you come to terms with what is upsetting you and you move past it. That's exactly how we have to treat fear. We have to recognize what is causing that fear and decide to move move beyond it.

Fear can not physically harm you but it will hinder you from living your life and pursuing your purpose.

There are two very different types of fear; rational and irrational. Rational fear is the type that is used to protect us from harm and danger. Let's say you are outside jogging and coming up the sidewalk you see a massive dog growling and running towards you. Rational fear is that inner instinct telling you to run in the opposite direction from the rabid dog that's potentially trying to attack you.

Then there is irrational fear; the type of fear that stops you from doing what's needed to take a leap of faith. This type of fear is usually associated with that little voice in your head that tells you to stop when you're ready to leap into a new, exciting opportunity. Irrational fear is also what tells us that if we take the leap we'll fail, that if we reach out for help we'll be laughed at or if we focus too much on promoting our products and services that we'll seem too salesy.

Let me ask you, what would you be able to accomplish if you stopped allowing fear to hold you back? Would that vision for your life that we talked about in the beginning of this book be a little easier to turn into reality? Would you finally have the courage to move from that idea stage and put forth the effort into starting your business? If I

wouldn't have let fear hold me back for as long as it did, I would have stopped downplaying what I knew and shared it boldly. I would have charged what I was worth and taken on any opportunity that aligned with my purpose but that would have also helped me to grow my business.

While I wish I could sit here and give you the antidote that would cure your fears and wipe away all of your insecurities, fear is inevitable.

Just like the other emotions you will experience throughout your lifetime, it is impossible to be 100% fearless. The myth that somehow we can overcome all of our fears and never experience the emotion again is a false narrative that we're often told by self-help gurus. But being fearless is an impossible goal to achieve. The goal isn't to ever feel an ounce of fear again, the goal is to learn how to be faced with fear and not allow it to hold you back. When you focus more on your actions, your fear becomes weaker.

As I sit here in my home office typing these words and pouring my heart out to you, I am terrified. I feel 100% unqualified to write this book but I know that the fear I'm feeling is irrational. The type of fear that has no other purpose but to stop me from doing what I have been called to pursue. I could have simply taken these thoughts and written them in a journal or just kept this book to myself but the fear of you not enjoying this book or no one buying it seems small compared to the fear I have of going through life without living on purpose.

I'll dig more into this soon, but facing fear always reminds me of how much we can't go about pursuing our purpose alone. I may be terrified to put my heart onto these pages but my God is mighty and courageous. The Lord

wants you to give your fears, your worries and your doubts to him because when you feel like you're too afraid to take the next step, you always have His strength to lean on. Find peace in knowing that the Lord is truly there to back you up every step of the way.

Identifying and Pushing Past Your Fears

"How do I get over this?" Is the question that I would constantly ask myself. They say the first step to recovery is admitting you have a problem and I knew without a doubt that I had an issue with being fearful. So I began calling out my fears, writing them down and asking myself, "What's the worst that can happen?" I would journal through my frustrations and the fears that I felt and instead of justifying them I would call them out as the lies they were.

Avoiding your fears, much like avoiding any other problem that arises in your life, will only make the situation worse. Ignoring our fears instead of facing them head on is also when we begin to see the other mental barriers like anxiety, comparison and self doubt begin to pop up.

To begin pushing past your fears, revisit that big purpose you dug into in chapter four and familiarize yourself with what you're working towards. Then I want you to think about where your fears are stemming from. What has caused you to have this fear? Think back as far as you can and make note of any experience's that may have played a part in you developing this irrational fear. For example, did your fear of starting a business originate from seeing how a failed business once affected your family?

This is the point when you'll need to get real with yourself.

My irrational fears stemmed from growing up in a single family household where money was often tight and the pressure of what I thought I was supposed to be doing with my life. Thus I was afraid of taking the leap out of fear that I would end up broke or that others would think I was crazy for not pursuing a traditional career.

The way to begin looking past these fears is to remember that you have control over many of the situations that you put yourself in. I had to realize that I could only become broke if I stopped working hard and became extremely careless with how I managed my money. I also had to realize that at the end of the day, I was the only one who was paying my bills, so the opinions of others on my career decisions didn't matter.

Go through each of your fears and get clear on the type of fear it is; rational or irrational. Then ask yourself what amazing opportunities could open up for you if you simply refuse to give this fear any more power and how you will feel once you allow this fear to stop controlling you. And lastly, think about what can you begin doing today to move past your fears. The best way to beat fear is to run towards it.

If you're currently afraid of writing that book the best way to make fear out to be a liar is to sit down and start writing. It will feel uncomfortable but nothing beats fear more than action. Your fears will become insignificant once you're able to look back at it instead of staring at it head on.

ACTION STEP: Head over to page 123 to complete The Fear Guide. This exercise will walk you through everything we discussed in this chapter and help you begin beating some of your biggest fears. Need more space? Pull out an

extra sheet of paper or journal and continue with the same prompts.

AFFIRMATION: Fear will not stop me from living my life on purpose.

Chapter 7:
Dealing With Your Inner Critic

"When you doubt your power, you give power to your doubt."
- Honore de Balzac

This book that you're currently holding in your hands didn't come out of nowhere. God actually gave me this idea a little over a year prior to me sitting down to write this chapter on doubt and silencing your inner critic during a time when I desperately wanted to be seen as an author.

I had been praying on a new book idea for what felt like months and remember the exact moment when it finally came to me. Originally, I figured since a lot of my blog posts were more strategic and my first book was a step-by-step guide to starting a blog, that my next idea would be more of a workbook that guided people on building another intricate part of their business. It was the safe route and well within my comfort zone.

But what God gave me was completely different than what I could have ever imagined.

The idea came to me around 6am in a dream right

before my alarm went off for me to get up for the day. In the dream I remember being in a bright room and seeing a woman writing at a bright white desk. I couldn't make out who she was or exactly where she was but as clear as day I knew what she was writing. The topic of "Why Women Don't Succeed" kept repeating itself over and over again in my mind.

While the details of the dream were extremely fuzzy, the topic was made clear. I jumped up and immediately began thanking God for giving me the idea for my second book.

Like most ideas that I've had in my lifetime, I was filled with excitement. After I had woken up, I immediately wrote down the details in my journal so that I wouldn't forget, then I ran to Target for supplies. I picked up a baby blue binder, a pack of loose leaf paper and my favorite ink pens. Once I got back home I began jotting down everything that came to mind as to what holds women back from succeeding.

I wrote down topics like fear, lack of support, comparison and yes, self-doubt. My heart was racing as I scribbled down everything that popped into my mind and I remember in that moment how fulfilled I felt. I just knew that this book was going to be my chance to be seen as an author and to make a big difference in the world of creative women.

After my burst of creative energy, I knew that writing this book would be a breeze. But after that morning, every time I would try to put my thoughts down on paper again, I felt overwhelmed.

I figured that writing this book would be no different than the hundreds of blog posts I had previously written or the "How To" book I had recently launched. I mean, God gave me the topic that I had been praying for, so the

writing process should have been easy...right? But this book was different. Unlike the "How To" articles I was used to, this idea would push me out of my comfort zone of just providing my audience with practical action steps. This book was more like the self-help books I loved to read and would force me to share pieces of my journey that I had suppressed.

So I tried to tackle it again. I sat down at my shaky glass desk to begin writing and as soon I was about to put pen to paper I froze up like I had just seen a ghost. And almost instantly I became consumed with self-doubt. The same topic that God had given me to help inspire other women to take action was the same thing the enemy was trying to attack me with. All of a sudden my mind was filled with lies that I quickly began to believe were true;

"Who am I to write this book?"

"You're still afraid of everything, who are you to talk someone through their fears?"

"You write about business, who are you to write a self-help book?"

And the most heart aching statement of them all –

"You're not qualified."

It felt as if a bunch of tiny doubters rushed into my mind all at once and completely swept away every piece of excitement I had felt about writing the book. I tried to write again the next day just to see if what I was feeling was temporary but was faced with the same voices. One day turned into three days, three days turned into a week. Instead of pushing past those insecurities and attempting to write at the least one sentence, I became so riddled with

self-doubt and believing that I wasn't qualified, that I placed that baby blue binder on my bookshelf and didn't revisit it again for months.

I blamed my lack of effort on still needing to do more praying to make sure that was the right topic that God wanted me to write on. Then I blamed it on personal reasons like not having enough time to sit down and write because we were in the middle of moving. I blamed it on everything imaginable except not being able to push past my own inner critic.

Self-doubt, which often stems from fear, is that little voice in the back of your mind that continues to tell you that you're unqualified, that you'll never be good enough, strong enough or smart enough. That doubt is what makes you believe that you have to wait for the perfect moment or for your current situation to change in order for you to take the next step towards fulfilling your purpose. Self-doubt is the cause of stagnation, complacency and existing.

Your mind can be both your saving grace and your worse enemy, it's up to you to choose which is worth listening to.

If I could travel back a year or so ago, I would have repeatedly reminded myself of how qualified I was. Who are we to think that God would give us a gift and a purpose just for us to fail? Of course, pursuing our purpose will be hard because it's meant to shape and mold us into who He wants us to be, but we are definitely not unqualified.

If God has called you to do something bigger with your life, then that means that he has equipped you with everything you need to make it work. You'll be amazed at the opportunities and guidance that will come your way once you surrender and trust that His plan will work in

your favor.

Once I finally let go of my own insecurities and realized that this book wasn't about me but the people whom it would serve, the process became a little easier. I've found communities of writers to lean on, received help from trusted authors and instead of me worrying about not having the perfect words, God has spoken through me throughout this entire book.

"She believed she couldn't, so He did." - Lara Casey

It didn't really hit me how much I was procrastinating on writing this book and how much doubt had held me back until one day I read one of my all time favorite scriptures, Philippians 4:13 (NIV), *"I can do all things through Him who gives me strength."* I knew right then that the reason why this book was so intimidating to me was because I was looking to myself for strength instead of the One who had given me the idea in the first place.

I know exactly how you must fee. Unqualified, fearful and anxious but we don't have to feel like we have it all together because God doesn't want us to. He wants us to go to Him for help instead of trying to figure it all out on our own. He is there to help us through digging deeper into our purpose as well as turning our purpose into a profitable business. When we feel like we don't have the power to push past all of our fears and doubts, that's when God steps in to fill the void.

What I know to be true is that whatever you feel like you can't accomplish, whether that be in business or life, you can always depend on His strength to lean on. If you don't

take anything else away from this chapter, know that self-doubt is the enemy of your success. As business owners we can not afford to allow our insecurities to stop us from stepping out on faith.

I've allowed both fear and doubt to run my entire life, from being afraid to speak up, to walking with my head down because I simply felt like I was unworthy of having or accomplishing anything greater. But as I dug deeper into understanding Gods grace and what I was put on this Earth to do, those doubts began to seem smaller and insignificant.

I pushed through and leaned on God's strength to write this book because I don't want you to make the same mistakes that I made. I want you to know that you are qualified – more than qualified, actually. So allow God to use that precious gift of yours. It's not going to do any good keeping it to yourself.

So how do you begin pushing past self-doubt?

Evaluate What You Are Consuming

We'll get into comparison in the next chapter but what you consume can have a negative effect on how you think of yourself. This is the biggest reason why I've placed affirmations and quotes throughout this book. What consumes your mind, controls your life. If you begin to focus more on the positive and what you are capable of doing instead of putting so much energy into what you feel you can't do, you'll be amazed at what you can accomplish.

I knew nothing about writing a self-help book but instead of using that as fuel to never begin writing I focused on what I could do, and that was doing the research and

asking for help. One of my favorite entrepreneurs, Marie Forleo, always says that *"everything is figureoutable."* When you're truly ready to make a change, you have to get your mind on board first, then figure out the rest.

What Is Causing These Doubts?

As a child we believe that we can be anything, from a doctor to a firefighter to Batman or a fairy princess. That childlike faith does not fade until the "real world" tells us that our dreams are either impossible or too hard to manage. We are constantly told by adults that our desires are unrealistic or certain failures that we experience throughout our life make us afraid to keep trying out of fear of failure.

A lot of the doubts I have experienced throughout the years have stemmed from simply wanting to please everyone. I was so terrified of what everyone else would think, that I either strived for impossible perfection or gave up on my ideas all together. Once I realized that the only person I had to make happy was myself, I was able to put that fear behind me and begin moving forward on the things that I really wanted to pursue.

Keep A Daily Gratitude List

Managing your self-doubt, again, has a lot to do with training your brain to think the opposite. Instead of dwelling on all of our imperfections or why we feel unqualified to tackle our purpose, keep a list of all the things that are working in your favor. If your thoughts are telling you that you're unqualified to open that new online shop, instead of putting your energy towards that negativity, be thankful

that you've been blessed with such an incredible idea and that you have a God who can easily put you in a position to learn everything you need to know to make that business happen.

Even if it's as simple as waking up this morning, get into the habit of counting your blessings daily.

Know That Everything Can Be Corrected Later

A lot of self-doubt is rooted in the need for perfection. Making mistakes are inevitable but instead of allowing those potential mistakes to hold you back from taking action, use them as a learning experience. Just like a bad relationship or a burned dinner, you can always try again and correct your mistakes along the way.

One of the biggest mistakes I made while digging into writing this book was not really thinking about the people I wanted this book to serve. Thus I began writing based off of an outline that was reaching the wrong audience. But instead of me scraping the entire idea and putting my baby blue binder back on the shelf, I used it as a learning experience and simply started over.

This book was formed from what happens when you dare to believe that God is capable of doing what you feel unqualified to accomplish. Again, don't doubt the gifts you have been given. There is someone waiting for you to share your purpose.

ACTION STEP: Go back through the action steps that I mentioned above. What can you begin to implement into your life daily to begin thinking differently about yourself

and pushing past those doubts?

AFFIRMATION: I am more than qualified to do everything that I have been called to do.

Chapter 8:
Comparison Is The Thief Of Joy

"Every minute you spend wishing you had someone else's life is
a minute spent wasting yours"
- Unknown

I have a love/hate relationship with the internet – let me explain.

Don't get me wrong, the internet can be an incredible space. It can be used to find and build your community, where you can learn how to begin building your business around your purpose and it's a safe space to shop during the holidays when the entire world has gone mad over the same toy and pair of boots.

But the internet is also a place where we often see the highlight reels of other influencers.

You log on and see a picture of someone's beautiful kitchen that is filled with natural light, neatly organized and filled with the most well behaved children you've ever seen. Yet instead of complimenting their space and scrolling to the next post, you begin to compare yourself to their "perfect" life. You then look at your own kitchen that is currently filled with dishes piled up to the ceiling and at

your kids who are currently finger painting with their food on your already dingy walls. Not to mention you have yet to find the source to the pungent smell that has been lingering around for a week.

And you say to yourself, *"My kitchen will never be like hers. If only mine were bigger or brighter or...better."*

Now insert how you've compared yourself to someone into that scenario. We've all been there and have compared someone else's life, business or Instagram feed to our own. Wallowing in self pity as we see someone else excel at pursuing their passion and purpose while believing we'll never make it to their level of success. Comparison happens and if it hasn't happened to you yet, I can almost guarantee you that it will eventually.

But if you want to move forward with your ideas and dig deeper into your calling, then you have to be fully aware of the comparison trap and how to avoid it. Every single day we are consumed with the perfect Instagram feeds, influencers with thousands of roaring fans and an even bigger bank account and the opportunities that others are landing that feel so out of reach for ourselves. Let's not mention how the internet can make us feel that if we are making anything less than six-figures, then we're obviously not running a real business.

Now there is nothing wrong with sharing your beautiful and happy moments, no one is obligated to show every part of their life. But you also have to remember that no one is perfect, and often what we see online is only what they are wanting us to see and not the full picture. You don't really know what is going on in their life the same way they don't know what is going on in yours. So why compare?

But I get it, I know how looking at what someone else has accomplished can make you feel. Like you're yet again, unqualified. That your goals will never be big enough or even if they are, that you'll never amount to that person's standard of success.

So you begin to look at your ideas, your product or your purpose as if it is insignificant compared to what everyone else is doing. But the issue with comparison isn't only the fact that you're focusing on someone else's journey rather than your own, it's that comparison can become such an ugly cycle to get wrapped up in. Often one tweet, comment or success story can lead us spiraling down a path of woe-is-me thoughts that are often too hard to dig out of.

And if we don't get the comparison under control quick, eventually we either push our own purpose to the side out of fear that we'll never live up to those around us or we begin to bend and shape our purpose to look like someone else's. Both having the same outcome – neglecting the gift you were called to pursue.

I've experienced my fair share of comparison throughout my career as I'm sure you have as well. When Periscope became the new and widely popular platform among business owners all of a sudden everyone was sharing their expertise via live video. Every few minutes I would receive another notification about someone going live. Being eager to learn, I'd tune in and be swept up into their message until I received another notification from someone else that I admired.

While I should have used seeing these influencers boldly share their story and knowledge as motivation for me to use this platform as a way to help me build my own

business and influence, I used it to point out what all I didn't have going on for myself. With every click into another live stream, the comparison became harder to break away from. Seeing how these incredible women were boldly sharing their purpose and expertise to hundreds of people online made me envious.

And it wasn't just through Periscope, I began to notice how my mind would dissect even the smallest details of someone's life or business on Twitter, Instagram and within their newsletters. I was a wreck, pulled into a dark hole that felt impossible to climb out of. The comparison I felt made me begin to doubt my purpose and question why I started my business in the first place. It was as if everything I ever wanted and knew in my heart to be true was now meaningless because my journey didn't match someone else's.

What I wish I would have known back then was that a lot of those feelings I had were irrational and that what I was actually doing was comparing my chapter four to someone else's chapter ten. The women I was comparing myself to had been running their business for years beyond my experience, so it made sense that they had a bigger brand with an extremely loyal audience.

Instead of using them for inspiration or simply stepping away and refocusing on my own goals, I tried to change my brand to perform like theirs, even if what I was doing didn't align with my overall purpose. I'd create classes solely based off the fact that they were making everyone else money. I would force myself to live stream everyday knowing that my poor introverted heart couldn't take it and I found myself selling in ways that made me feel gross.

Comparison had created a monster and I was in too deep to pull myself out. As months passed, I got farther and farther away from what I originally wanted from my business which was helping women like me dig deeper into their purpose through entrepreneurship.

Creating content became harder, making money became exhausting and actually enjoying my business was non-existent. All of a sudden I felt like I was back on that call center floor. Completely drained and feeling like I was further away from my calling than ever. I was so busy trying to imitate someone else's life, that I didn't realize I was neglecting the life that I was created for.

I felt defeated.

I thought by following what I saw the other influencers doing would make me liked, would help me take my business to the next level or at least would get people to listen to the powerful message I knew that I had inside of me. But all I felt was more confusion in my business and envy for those who were still racing past me. And for a moment, I saw no other option but to close my business for good.

Galations 1:10 (NIV) says, *"Am I now trying to win the approval of human beings, or of God? Or am I trying to please people? If I were still trying to please people, I would not be a servant of Christ."*

God has placed these gifts within you to serve him and those who need what you have to offer, not to please everyone that you come into contact with. I didn't understand at the time that we can not serve both God and man. My need to be seen as an expert, to be liked and praised took over my desire to continue to discover who I was.

I was existing.

We all have different strengths and weaknesses. There is not a single person walking this Earth who is genuinely great at everything that they do; not even Oprah or Beyonce. Which is why we have been given specific gifts that allow us to dig deeper into what we are naturally good at. By comparing yourself to someone else, you could be comparing your weakness to their strength.

That person you're envious of has been specifically called by God to pursue their specific strengths. Instead of developing our own, we end up spending more time working hard and trying to be great at something that we were never meant to do. If you are chasing someone else's dream or purpose, you'll always find yourself performing at an average rate or burnt out from making your journey harder than it needs to be. Why fit in, when you were born to stand out?

That was the issue that I kept running into; I was trying to tell myself to be comfortable in my own skin while constantly trying to replicate someone else's. I was burnt out and literally exhausted with trying to keep up with the Jones' that I figured quitting was my only option. Quitting would have been easy but would have also set me back further than comparison already had.

Not to mention I had no clue what I would have done with my life had I decided to quit. I promised myself that I would never put myself back in a situation like I was in when I worked at the call center and at this point, I hadn't had a full-time job in years so in the corporate world I was probably unemployable.

What other options did I have?

So I decided to pray. Throughout me chasing someone else's purpose, I kept feeling God nudge me with quiet whispers telling me to step back. But I had success on my mind and knew that if I wanted to hit the level everyone else was on then stepping back wasn't an option. But at this point – stepping back was all I had.

I stopped the rat race and surrendered to God. I prayed like I had never prayed before and asked Him for clarity. Know that no matter how far deep you feel you have gotten or how far off the path you have strayed, God is always there to help you get back on track. Just like when we're talking about uncovering your purpose, often God just waits for us to surrender and wholeheartedly ask him for guidance.

It wasn't until I took a step back, that I realized how big of a hole I had dug myself into. I had previously made so much progress from being that girl who had nothing but ideas with little motivation to being someone who was relentlessly going after her dreams. But here I was, back to feeling like I had no clue what I was doing or the direction I was going in. The same feeling of emptiness I once had before knowing that I needed to make a change. Only this time, I knew exactly where my problems originated from.

I had spent so much time watching other people grow in their purpose, consuming so much content and listening to the "shoulds" of the internet that I had completely let go of the vision that I saw for myself. Whenever I would receive a new notification that someone was going "live," I would stop whatever I was doing to tune in. I would dissect someone's email sequence and point out all the things I was doing wrong in my own. And I'd scroll through my social feeds for hours until my head began to hurt from the brightness on

my screen. As silly as it may sound – I was addicted. I knew that the only way I could break my addiction was to listen to God as He was telling me to step back and to purge what I was consuming.

To break out of the comparison trap, I knew I needed to cut myself off from everything that made me envious or that distracted me from the path that I was on. I started by deleting apps off of my phone that didn't serve me or my business, including Periscope. And I changed the settings on the apps that I kept, so that I didn't receive any new alerts or notifications. That way I could focus on my own work throughout the day without feeling the need to pick up my phone every few minutes.

I went through and decluttered my inbox and unsubscribed from everyone's newsletter. I also put a limit on how much time I spent scrolling through social media in exchange for reading and working on my own strengths. And when the urge to push past that limit came up, I would put my phone in another room until I completed whatever I was working on. Not only did this help my productivity, but little by little I began to feel like a huge weight had been lifted off of me. By cutting back on what I was consuming, I no longer had anything or anyone to compare my journey to.

I also picked up new habits that allowed me to dig deeper into who I was becoming and that strengthened my relationship with God. Instead of instantly jumping on social media in the mornings, I started my day journaling and reading my devotional. To continue to remind myself how grateful I was about my specific journey, I began writing out a gratitude list every night. Slowly, my original

purpose became a little more clear and I was getting the clarity that I had been praying for.

Getting past comparison meant retraining my mind to appreciate the unique path I was on and to truly see the value in the areas I was good at. It also meant training myself to be able to compliment another creative who was creating or saying something brilliant, instead of over analyzing and putting my life up for comparison.

This process helped so much that I no longer felt like closing my business was my only option. Instead I took a month off from actively working in my business to do some brainstorming and to get back aligned with my purpose. Slowly but surely, I felt like I was digging myself out of the trap that comparison had placed me in.

After my break, I came back with a bigger message and an even clearer understanding of what I was being called to do; to help creative women who were like me to live their life and create their business on purpose. I adopted that motto across my personal brand and it is also the basis of this book because I never wanted another woman to feel like she wasn't good enough because her journey did not look like someone else's.

Just like fear, and every other mental obstacle that we talk about in this book, comparison doesn't have a cure. There is no way you can go through life and never again think, "Wow, I wish my kitchen...home...or business were better." but what you can do is not allow it to box you in. Know that you have control over your thoughts. When faced with comparison, you have the choice to either give props where it's due and keep it moving or let those feelings consume you and throw you off track.

This entire journey of pushing through these mental obstacles is about embracing your feelings but remembering that you have the power to not allow them to derail you. Instead of allowing things like comparison to put you in a bad space mentally or emotionally, train your brain to walk away and focus on what truly matters.

ACTION STEP: If you're currently dealing with comparison, what in your life can you change or get rid of in order to separate yourself from those distractions? Don't just write out your ideas, begin implementing them immediately.

AFFIRMATION: I will not compare my life or business to someone else's highlight reel.

Chapter 9:
Releasing Anxiety

"Anxiety is the natural result when our hopes are centered in anything short of God and His will for us."
- Billy Graham

With a simple Google search of "How To Start A Business," you'll see that over 812 million results will populate.

Needless to say, figuring out the HOW behind getting your business started, is the least of your worries. Throughout this book we have been on a journey together to combat some of the biggest mental obstacles that may be holding you back from even getting to the "how" stage. As I've mentioned before, getting past these mental obstacles are step one in your journey to successful entrepreneurship.

I only wish that our creative community had more conversations about how hard starting or growing a business can be. The late nights, the disappointments, the stalking your stats to see if your following has increased. Mix that with the fear, self-doubt and comparison that

comes along with building your brand and you're bound to feel anxiety begin to creep in.

Back before I quit my job at the call center, I had no clue that heaviness I was feeling in my chest and the constant state of worry I was in was actually a side affect of anxiety. If you're unfamiliar, anxiety is a feeling of worry, nervousness, or unease, typically about an imminent event or something with an uncertain outcome. I had heard of anxiety mentioned before but never put too much thought into it because I was one of those people who felt like they were invisible to having a mental illness.

In my community, and in most black communities, anxiety often isn't considered to be a real issue. Instead we call out those feelings of worry as being too sensitive or even crazy to an extent, instead of digging deeper into what is causing us to have these side effects. And if you are a woman, what you're feeling is often blamed on PMS.

Even if what you are feeling does become something that we feel we are unable to control, you're often told to simply pray about it. Talking about anxiety is taboo and going to speak with a therapist was only something that "crazy" people did.

According to the Anxiety and Depression Association of America; anxiety disorder is one of the most common mental illnesses in the U.S and affects over 40 million adults with women being the majority.

So why us?

Studies have shown this is because as women we put more weight on our shoulders to be the best and to outperform. In a world where men are often favored over

women, we feel the need to work harder, stay in the office later and put forth the extra effort just to be seen as their equal. Especially when it comes to running your own company.

If you have suffered or currently suffer from anxiety, then know that you are not alone. Also know that you can also create and run a successful business without the fear of your anxiety holding you back.

After I had my meltdown in the bathroom of my former job, I assumed it was all caused by the stress I was under. I figured that if I could remove myself from that toxic situation, then I'd never have another meltdown like that again.

While I can honestly say I haven't had a breakdown in the middle of a public bathroom floor like that one since, anxiety has stuck with me over the years like an evil twin. Becoming an entrepreneur was one of the best things that I've ever accomplished in my life, but it didn't stop anxiety from constantly trying to attack me.

I've found myself sneaking into the other room away from family and friends on multiple occasions to quietly cry to myself because I was so overwhelmed. I've scarred and bruised the inside of my cheeks with my teeth because I was trying to hold back my tears when I couldn't find a place to run to. And I've lied and said that something was irritating my eyes when asked if something was wrong with me when the tears became apparent.

The heaviness I have felt in my chest has made me fearful that I was about to have a full blown asthma attack and the roller coaster of emotions that I've felt have made me put my business and life on hold plenty of days in exchange for

staying in bed. I didn't know how bad my life was affected by anxiety until I became a business owner.

The pressure of building a brand; a brand that people would actually give their money to support doesn't make it any easier. But I don't mention all of this to scare you or to make you feel that if you have these symptoms then you'll never be able to start or grow a business of your own. I say this to show you that despite the unpredictable emotions, the heaviness on your chest and the frequent tears, building a brand around your purpose isn't impossible.

The emotions you feel throughout the day are just that – emotions. Just like you can feel fear without allowing it to hold you back, the same goes for anxiety as well. What you're currently feeling is something one in five adults go through on a daily basis so don't think for a second that you are alone.

The best way to begin tackling anxiety, just like fear and self doubt, is to be clear on where it stems from. Anxiety can be caused by past failures, the need for perfection or an irrational fear. It can also be caused by placing so many worries and tasks on our own shoulders that our minds literally begin to break down.

I've come to the realization that a lot of my anxiety over the past few years has come from my desire to always be in control. Blame my Type A personality, but I wanted and needed everything to go my way and on my schedule. It has always been hard for me to give over control or to trust people with tasks that I am passionate about, thus I try to manage it all and put all the worries on myself when tasks could easily be delegated out.

The more I pushed for control, the more anxious I became. The more I worried myself with trying to figure out how to grow my business and how to increase profits all while trying to live a normal, stable life, the more anxiety barreled on top of me like a ton of bricks. I imagine God sitting up there with his arms folded while shaking his head and telling me, "Nope, try again."

Philippians 4:6-7 (NIV) says, *"Do not be anxious about anything, but in every situation, by prayer and petition, with thanksgiving, present your requests to God. And the peace of God, which transcends all understanding. Will guard your hearts and your minds in Christ."*

What the writer Paul is saying in this passage is that you literally have to surrender and give everything over to God if you truly want to experience peace in your life.

It took pushing through comparison to begin believing in myself again and it was going to take anxiety for me to turn around and put that belief in God. But I was stubborn and liked doing things my own way. Forever needing to know what was going on at all times and needing a plan for every inch of my life and business.

Again, all God was wanting me to do was surrender my weaknesses to him and ask for help. The more I continued to pile on obligations and worry myself silly with my neverending to-do lists, the more I felt anxiety begin to not only take a mental toll on me but I also started to feel the physical effects of it as well.

I would have migraines that would make it hard for me to be in a room with too many lights, I had to walk around with an asthma pump in my purse out of fear that at any moment I would have an asthma attack and the stress made

me physically exhausted which made me want to do nothing more but to stay in bed.

So how do you begin to manage your anxiety?

Speak with a therapist. First I would suggest seeking professional help. Yes, you can pray through anything that you are faced with but I also feel that God has put therapist on this Earth for a reason. Dealing with any type of mental illness needs a little extra help outside of prayer. Don't be ashamed of going to to speak with someone who is trained and licensed to dig deeper into what's causing you so much anxiety.

Seek God. A combination of both professional and spiritual help is a great concoction for managing your anxiety. Like I mentioned before, God wants us to go to Him for the areas of our life that we need help with. Bottling it all up and trying to figure out a plan for all of our issues is the best way to destroy your peace.

I will say that dealing with anxiety over the years has actually strengthened the relationship that I have with God. Because of it, I now know more than ever that I need Him and that He has to be made a priority in my life if I want to keep it all together without becoming emotionally overwhelmed.

Starting each day with prayer, journaling and reading my devotional helps me to lessen the anxiety that I feel throughout the day and makes me feel like I'm not the only one in control over my life, business and the decisions that I need to make. Find comfort in knowing that you can seek God for anything, both big and small, and again, find peace in knowing that He always has your back.

Prioritize self-care. Caring for yourself isn't selfish, it is necessary. It's important, especially as a business owner who is constantly networking and connecting with people online, that you take some time to disconnect and make time for yourself. You can't perform at your best if your health is lacking.

Take some time out for you to do the things that help you to relax and refocus. That can be taking a nap, picking up a new hobby, exercising or simply binge watching your favorite tv shows. I often take breaks from taking on new clients or launching new products in order to take time out for myself and to put my focus on other aspects of my business.

Learn to say "no". Attempting to be everything to everyone is impossible as I'm positive you will learn quickly. At one point I was wracking my brain trying to answer every email, cater to every single client and say yes to every collaboration that came my way. While everyone else was happy, I was mentally and physically exhausted. My anxiety was at an all time high, I was frustrated, annoyed and began to resent the work that I was doing instead of enjoying it. I had no clue how I would manage it all until one day I realized that I didn't have to.

Saying no can make you feel like you're disappointing everyone, but when it comes to a matter of being healthy and not sparking your anxiety, putting too much on yourself is not worth it. And those who genuinely care, will understand.

Also remember that "no" can be a complete sentence. You don't owe anyone an explanation or apology for doing what is best for you.

If you're reading this and thinking, *"Alisha, I don't struggle with anxiety, how is this supposed to help me?"* Then consider yourself blessed to not have to deal with it.

But I also want you to remember that anxiety can flair up at any time. Anxiety isn't something that you are born with or a disease that you catch from another human, it can literally raise its head as soon as you begin to put too much pressure on yourself to turn this idea of yours into a successful business.

So while you may not experience anxiety now, and I pray that you never will, I hope that this chapter gives you a better insight into what others are going through and how you can be prepared if it were to ever happen to you.

ACTION STEP: In what ways can you begin to eliminate anxiety in your life? Go back through the steps above to create your anxiety escape plan. If you don't struggle with anxiety, what can you begin to change in your life to try and prevent anxiety from coming up in the future?

AFFIRMATION: Anxiety is not the ruler over my life. I will not allow it to cripple me.

PART IV:

Faith and Action

Chapter 10:
Building Your Faith

"Faith is to believe what you do not see; the reward of this faith
is to see what you believe"
- Saint Augustine

Everything that I thought I knew about faith, I learned in church as a kid.

We attended a fairly large store front style church made of brick in the heart of my hometown. We were the family that attended every Sunday, Wednesday and Friday service faithfully, so one of my most vivid memories as a child was trying to not get caught dozing off in the pea green colored pews. But during the times I was awake, I'd look over the chairs and gaze at everyone's excitement during service.

People of all ages would run around the sanctuary, screaming and praising God, while the pastor preached and prayed in the background. I remember when people would get prayed for, right before falling to the ground the pastor would say that they needed to have faith. Back then I thought their excitement had to be what faith was; believing that God was real and being excited to be in His presence.

For the majority of my life after moving out on my own,

that's what I believed. That if I simply knew that God was real and clapped and praised during church service, then I had faith.

But little did I know that having faith and practicing faith were not the same.

I would attend church regularly but would still be filled with so much anxiety because my mind would be running a mile a minute with all of the things in my life that I needed to figure out. I would claim to know and understand how truly blessed I was, but count myself out of getting new opportunities to grow in my business because I didn't feel like I was qualified. I knew Jesus, the story which I had heard over and over as a child in vacation bible school, but I really didn't know how to connect Him with having faith.

Remember when we were talking about digging deeper into your purpose and I mentioned that we should dig back into that childlike faith? As a child you are literally unstoppable and you know without a doubt what you wanted to grow up to be. You courageously shout it out loud and don't mind telling everyone that you come in contact with about what you want to do when you became an adult. But as you get older, the world begins to point out our weaknesses.

The world tells you what is realistic and what is too far fetched. The world also often tells you to reconsider your dreams, because to them, you won't be able to make a career out of it. Thus, you either land in a cubicle job that you hate, while pursuing someone else's idea of success or you spend your time wandering around aimlessly trying to figure out what you were called to do.

With faith, regardless of what you're told by the people

of the world, you know that all things are possible.

As business owners, we need to be able to tap back into that childlike faith. Not to be naive, of course, but to truly feel down in our soul and believe with our entire being that all things are possible with God's help. Our dreams, our goals, the opportunities that we desire and the doors that we want opened up for us, can all be made possible if we truly have faith.

Many business owners struggle to push past the idea stage and their fears simply because of their lack of faith. Instead of focusing on what they can do to start or grow their business, they focus on their weaknesses or the grand scope of their dreams. Which in turn, makes their desires feel too impossible to accomplish.

Faith, according to Hebrews 11:1 (NIV), is *"the substance of things hoped for, the evidence of things not seen."* Simply put, faith is the trust, assurance, and confidence, that God will show up and make incredible things happen in your life, even if you can't see those blessings at the moment.

Having faith means stepping out into your purpose and knowing without a shadow of a doubt that God is going to supply you with everything you need to live an abundant, purpose-filled life. And yes, that often means giving up control and placing your goals and desires in God's hands while believing that He is going to work everything out for your good.

Think about all of the times you may have needed Gods help when you didn't see a way out of it for yourself. There were plenty of times when I was looking for a full-time job right out of college that I would look at my check, compare it to the amount of bills I had to pay and couldn't do anything

but cry because I had no clue how I was going to pay it all. In those moments I would plead and ask God for help, and sure enough, even when I couldn't see how all of my bills were going to be paid, they were. I would open my mailbox and find an unexpected check for the exact amount I needed to pay bills. I would be blessed by a family member or my check from work would be slightly more than what I was expecting.

And you know what, God has always shown up for me when I needed it the most because He promised you and I that if we had faith and gave our cares to Him, that he would supply all of our needs.

When we know something is true purely based on the evidence we are exposed to – *that is faith.*

Faith is an action – it convinces us that what we cannot see is possible and it gives us assurance in what we have been hoping for. This is why it's important to backup your ideas and purpose with faith. I won't lie to you, running a business is hard, as you can tell from my journey. But what has kept me afloat all of these years and not giving up when times were rough was my unwavering faith. During some of my darkest times when I wanted nothing more than to let go of it all, my faith was what got me out of bed most mornings.

In those moments when I was sitting in that call center job trying to figure out what I was going to do with my life, is when I discovered what faith really was. God promised us that He would never leave us or forsake us. And when He got me out of that position that left me crying on the bathroom floor, I knew that I needed to infuse Him into everything that I created and every decision that I made.

I went back and forth with myself a lot when I started writing this book, because I wasn't sure if I wanted to add scriptures or even talk about my journey with God. I never want anyone to think that I am just preaching at them or that I'm trying to convert their beliefs over to mine. But I realized that my faith and Gods love is the reason why I am here today.

While my relationship with Him hasn't been perfect and there have been times when I have questioned my beliefs, I know that everything that I have accomplished, I have been able to do because of Him. I know that when my dreams begin to feel TOO big and TOO grand or when running a business begins to feel suffocating, that He always has my back. The same way that He has yours.

To truly begin tapping into your purpose, succeeding and using the gifts that you have been given, you have to have faith in something bigger than yourself.

Unfortunately, simply saying that you have faith isn't always enough. Especially when you begin to feel like the bad is outweighing the good in your life. I am what you call a "chronic worrier". At the sight of trouble or a situation that I am unsure how to get out of, I instantly go into panic mode and my mind begins to race with every worst-case scenario imaginable.

"I'm going to go broke and have to get a job that I hate."

"If no one buys, that means I'm a failure."

"If I'm a failure, how will we pay our bills?"

It sounds ridiculous, but I'm sure at one moment or another you've had this happen to you as well. As soon as you are no longer in control, your mind goes into overtime

with doubt and ridiculous solutions to your problems. But what I have learned over the years (and honestly still learning today) is that worrying won't solve your issues quite like faith will. All worry will do is cause more stress and block you from listening to what steps God is trying to tell you to take next. With faith, although panic may turn up, you know that you can find peace in knowing He has your situation under control.

So how do you begin strengthening your faith?

For starters, look at faith, or anything that you want to get better at for that matter, like physical exercise. The only way to get physically stronger is to consistently work out and lift weights. With consistent practice, you begin seeing results. Look at your spirituality or your faith the same way. The more you pray and spend one on one time in His presence, the stronger your strength becomes. I mentioned before that your prayers don't have to be these big grand chants, but simple conversations between you and God. So don't overthink it.

Make spending time with God a part of your everyday life. I try to spend the start of every morning meditating, praying and reading my devotional. In those quiet moments you spend with Him is when your faith begins to strengthen and you get a better understanding of what He needs from you.

You would think that after landing countless jobs that ate away at my confidence and constantly pushing through the obstacles like fear, comparison and anxiety, that I would have given up and thrown in the towel on my purpose. While the thought crossed my mind hundreds of times, instead of looking at those disappointments as there was no other way

out, I used them to gain understanding that God was still planning something bigger for me.

With every job rejection, every unanswered email and every sale that went unpurchased, I believed that even if it didn't work out for me in those moments that eventually it would all make sense. And it did. If it wasn't for that break down I had at my job, I would have never been pushed to further explore full-time entrepreneurship. And if it wasn't for me starting my online shop, I would have never began coaching and helping other women start their businesses.

And if it wasn't for building my personal brand, I would not be sitting here writing this book. Had I allowed those disappointments to block my blessings I would still be sitting in that cubicle wishing I was doing something bigger with my life. See, your delay does not mean denial. Just because you can't see the light at the end of the tunnel just yet, doesn't mean that it isn't there. It just means that you have to keep pushing forward in order to reach it.

That's where having faith steps in.

I try to tell my clients that there really is no such thing as failure. While certain situations and projects we try in our business may not work out with the outcome we were hoping for; it leaves us with an incredible learning experience which automatically puts us ahead of those who refused to even try. To begin strengthening your faith, look at those no's as a delayed yes. Look at those disappointments as if God wants you to dream bigger and that you will be gifted with an opportunity that is better than what you could have ever imagined.

The more you meet your fears, excuses and weaknesses with faith, the stronger it becomes. When faced with a tough

situation, immediately begin to pray and give that situation over to God. Find peace in knowing that He is faithful.

What To Do When Your Faith Is Tested?

About mid way through writing this book I began to feel like I was being hit with every mental obstacle that I was writing about. From not feeling like I was qualified, to comparing myself with other, more established authors to feeling overwhelmed with anxiety that stopped me from writing on plenty of days.

Having faith doesn't mean that everything is going to go your way. It doesn't mean that your life is now perfect or that you'll never experience another hard day. If that were the case, I'd be writing this book somewhere on a private island and not currently in a corner in Starbucks. Often right when we feel like our faith is in a good space and that nothing can stop us, is usually when the enemy tries to attack you and steal your peace. Having faith simply means that you know no matter what may come your way, that you will make it through to the other side.

Romans 8:28 (NIV) says, *"For all things work according to His perfect will."* Meaning you have to exercise your faith and know that God has already worked out your business, your life and your current situation, exactly the way it is supposed to go. And know that what He has planned for you is often better than anything you could have ever imagined.

I just wanted to make a living that wouldn't involve someone telling me when I could and couldn't leave my desk, never in a million years did I think I would be here today.

ACTION STEP: Grab a notebook and dedicate a few moments to spending time with God everyday. You can start by taking one scripture, writing it down and journaling through what it means to you and how you can apply it to your life. Journaling your prayers is also a great way to begin strengthening your faith and building a deeper relationship with God.

AFFIRMATION: My faith in God exceeds all of my fears and insecurities.

Chapter 11:
Take Action

"The path to success is to take massive, determined action."
- Tony Robbins

Throughout this book I have guided you through the process of deciding that at this moment you are ready to make a change, you've uncovered or dug deeper into what you feel you are being called to do, you're clear on what's holding you back and how to begin pushing past it and you've began to strengthen your faith. So what's next on this journey of pursuing your business idea and living a purpose-driven life?

Now, it's time for you to take action. Just as I mentioned at the beginning of this book, no coach, mentor, guru or e-course will do the work for you. Neither will simply reading through this book and placing it back onto your bookshelf. In order for you to begin seeing results, and for everything that we have gone over up until this point to work, you need to put action behind your desires. Which also means no more excuses.

For a long time I hid behind not knowing what to do

with my life as an excuse for why I wasn't moving forward or making any positive progress. But once I began to dig deeper into my calling, I then hid behind being too afraid. And once I pushed past those fears, and couldn't come up with another reason as to why I couldn't pursue my dreams, I realized that I was just comfortable with making excuses.

Taking action doesn't necessarily mean pouring your life savings into this new business and hoping for the best or quitting your job because you feel like your faith can carry you. Often taking action means making small steps that will eventually lead up to a bigger purpose or goal. Small movements, like purchasing your domain name or even telling your social media followers about the business you're starting, is better than sitting back and doing nothing at all.

One of the biggest reasons why I had you take small action steps throughout this book is because I want you to look back and see what you have accomplished since you started reading. Even if you're not 100% sure what you are being called to do or if you still have those thoughts of self-doubt popping up, I'm sure your mindset is a lot different than it was before you picked up this book – assuming you did the work.

Before you begin to look through your schedule and already get it in your mind that you won't have the time to really work on this business, go ahead and stop that limiting belief now. Because you will find a way to make time for the things that you care about. The same way we make time to binge watch hours of our favorite tv series on Netflix is the same way we can prioritize putting energy into developing our purpose.

So I get it – life gets hectic. Right now you probably have a small child that is begging for your attention, or in my case, a beagle. Or you may have a demanding full-time job that barely leaves time for you to breathe. A full class workload or hundreds of other personal obligations that require your presence. But if you made it this far into this book, then I can only assume that you feel like your purpose and your ideas are worth taking on the risk.

Instead of waiting for your personal life to become less chaotic (hint: it never will) or waiting for the perfect moment to start, make your purpose a priority and begin taking small steps towards what you desire.

The number one reason why most people don't make it past the idea stage is because they lack self-discipline and motivation. You have to want this for yourself and be self-motivated enough to get started without anyone coaching you or holding your hand. Unfortunately, self-motivation isn't something that I or anyone can teach you. You've already made the choice to change back in chapter two, so now you just have to commit to taking action.

So, where do you start?

What Do You Want and Why?

In order for you to create an action plan, you have to know what you want and the why behind making this business happen. If you struggle with self-motivation, reminding yourself of the bigger reason behind why you're taking this risk will often be that push you need to get up and work.

Let's start off by thinking about what you want,

specifically for the business you are building or planning to create. I have been a huge fan of creating a vision board since I started creating them as a child in church.

Every New Year's Eve our pastor would recite Habakkuk 2:2 (NIV), *"Then the Lord replied: Write down the revelation and make it plain on tablets so that a herald may run with it;"* then instruct us to write down our goals for the new year. There is something powerful about getting your dreams and desires out onto paper and is a practice that I often have my coaching clients do to help them see past their limiting beliefs.

You can use an actual poster board to complete your vision or record it in your journal. The most important aspect of creating your vision is that you allow yourself to dream without any limitations. If you see your business being featured in Forbes, then write that down. If you see yourself being interviewed by Oprah, then add it to your vision. The purpose of a vision board is for you to get excited about reaching the goals you have been dreaming of and to begin manifesting them into reality.

Next you want to make note of WHY you are pursuing your purpose and why you are adamant about turning it into a business.

When I started my personal blog, I was struggling to keep my online shop afloat, and the lack of information that I found online to help me was disheartening. So when I stepped out to commit to blogging about my journey as a business owner, I knew that my reasoning would be so that no one else would have to make the same mistakes that I once made. Even if it meant me sharing parts of my story or business that weren't so pretty, I knew I wanted to become

a helpful resource for other creative women that I didn't feel like I had.

Take a moment and think about your why. Is your main goal to pay off all of your consumer debt so that you can breathe easier every month? Is it to finally get out of that full-time job that has been causing you constant migraines? Or is to simply help send your children to college so that they won't have to be consumed with student loan debt like you were? Think of the bigger reason beyond the shiny things that your business could potentially buy you and beyond the fame and the popularity.

Not only will getting clear on your why motivate you to take action, but from a branding standpoint, your why is typically what will draw your audience towards your business. I tell my clients often that people are more likely to fall in love with a person before they fall in love with a brand because of the story that's behind it. It is why many of us would rather shop local than go to one of the many Wal-Mart's in our city. We know that the local grocer is giving back to the community, whereas we can never put a name or a face to the person who runs Wal-Mart.

Action Step: Gather a few supplies (or your journal) and take some time to create your vision board. Also make note of the bigger reason behind taking this journey.

Create a Routine or Schedule

Let's go back to your busy schedule. I'm sure there is not one person on this Earth who doesn't have a lot going on or who doesn't have other personal obligations outside

of spending all day on their business. So we're no longer going to use lack of time as an excuse. Instead, I want you to evaluate your day and come up with time that can be strictly dedicated to your business. Depending on what all you have going on, that may mean in the season you're currently in, sacrifices will be necessary.

When I was still working in the call center, I would sneak in a few of my jewelry supplies so that I could fulfill orders while on the phone. And on my lunch breaks, instead of socializing with my other co-workers I would sit in my car and read or answer emails while I ate. I made sacrifices because I knew that working eight hours a day would only leave me a small window to work on my business.

What would making a sacrifice look like to you? Instead of catching up on your shows on Saturdays, maybe you'll have to use that time to work. Or maybe for you it means sacrificing your sleep and waking up a few hours earlier to get some work in before heading off to your job.

When I started to take this book seriously, I had a full client load, I was planning my wedding and had different projects that I needed to release. Instead of waiting until I was married and settled into becoming a wife or waiting until my client contracts were up, I committed to waking up at 6am every morning (yes even the weekends) to work on this book and often stayed up well past midnight.

Not to sound harsh but if you don't believe that your dreams are worth the sacrifice then maybe entrepreneurship isn't for you.

ACTION STEP: At what times or days are you willing to

give your purpose your undivided attention?

Be Aware Of Those Mental Obstacles

Just because you feel like you may have good control over fear, self-doubt and comparison, does not mean that those emotions will go away for good. Remember, there is no such thing as being fearless.

Nothing sparks these barriers quite like finally deciding to take action. It's as if the moment you decide put pen to paper or make your first big decision, all of a sudden something clicks in your head that tells you *"This idea isn't not worth your time."* or *"You'll never be able to make that happen."* But unlike all of the other instances in your life when you've probably allowed these emotions to get the best of you, you are now equipped with how to handle them and also how to spot them early on.

Whenever you feel those emotions or thoughts creep back in, flip back through this book to the obstacle you are facing and refresh your memory on how you can gain back control.

Create Clear and Attainable Goals

Now that you have created your vision, you have to create an action plan that will help you to turn what you desire into reality. The only way to do that is to create a list of attainable goals.

Instead of looking at your vision board and saying, "Ok I'm going to set out and make $100,000 this year," you need to break that goal down into smaller steps that will work together to help you to reach that bigger goal.

If you want to make $100,000 per year, then that means you need to make roughly $8,333 per month. So what do you need to do within your business in order to make that amount?

First you would need to make sure you have something to offer, whether that be products or services. Then you would also need to make sure that you have a marketing plan in place that will attract customers and also prove to them why they should invest their money into you. So much more goes into accomplishing a goal than just saying *"I want to have this completed."*

Let's say that you are just starting out and your goal is to simply get your website up and running. Then instead of trying to tackle that goal head on, break it down into smaller, less intimidating steps. How about you pick one day that you want to purchase your domain name, then set a deadline for you to choose a hosting platform, and then another to actually book and hire a designer.

Remember, small steps are better than none. Trying to achieve our entire goal without breaking it down into smaller goals, often won't do anything but leave us overwhelmed. And when you are overwhelmed, how likely are you to accomplish anything?

My guess is not likely at all.

Find An Accountability Partner
I am often asked why I have no issue with sharing my ideas on the internet for the world to see. That's because I use my followers as accountability partners. I never want to let anyone down or seem like a flake to those who have built

their trust in me, so in order for me to stick to my goals, I share it with the internet. It sounds crazy, but trust me it works.

It is a lot easier to give up on our goals when we know there is no one around to hold us accountable. If you never tell a soul that you have decided to turn your idea into a business, then you won't have to face explaining yourself in the event your ideas blow up in your face. Often we say we're not going to share our ideas because we don't want anyone to steal them, but I've learned that it is usually because we plan to use our secrecy as an easy out in the event that things go south.

Find someone in your community or someone that has similar goals as you, to be your accountability partner. Share with them what your big goals are and ask them to check in with you and hold you accountable. You will be amazed at what you can accomplish when you know that there is someone who is going to check in on your progress. Just keep in mind that these types of relationships should always be beneficial to both parties. If someone is holding you accountable to your goals, in return, ask them what you can do to help them meet theirs.

If you're unsure where to start with finding an accountability partner, I run a Facebook Community called Living Over Existing, that is filled with other like-minded women who would love to support you.

You my friend, were placed on this Earth for a divine reason that is just waiting for you to break out of your shell and allow it shine. What you have been called to do may possibly change the world, a single person or your life all together. But you will never know what you are capable of

until you take a step forward and try.

I hope through reading this book that you have gotten a better understanding for what you have been placed on this Earth to do and I hope that it has lit a fire in you to work towards it with all of your mite.

Most importantly, I pray that this book has given you a deeper understanding of how you can take back control over your life and no longer be held down by fear, comparison, self-doubt or anxiety. Know that God is on your side and that I am here constantly rooting for you.

Now go live on purpose.

The Fear Guide

Fear is the root of what causes the majority of our doubts, anxious feelings and overwhelm. I fully believe that if you can tackle your fears, then tackling the task of building an online business will be a lot less stressful. I created this guide to help you to not only call out your fears for the major lies that they are but to also provide you with space to create a plan for you to push past what you feel is holding you back. If you need help, reference back to chapter six.

YOUR BIG PURPOSE

We all have a big, grand vision for our life and our business. There are so many things we want to accomplish but don't even begin to scratch the surface on because of fear. In the space below write out exactly what you would do if your current fears didn't exist. What would you accomplish? How would you feel? At the end, ask yourself if this big vision is worth pushing past those fears.

Is this vision worth pushing past your fears?

IDENTIFY YOUR FEARS

Use the space below to get clear on your fears and where they stem from. Calling out our fears for the lies that they truly are makes them a lot less scary and not as big as our minds have made them up to be. Next you'll want to think of some action steps you can take to begin conquering each fear. I've also provided you with an example for reference.

1. **What is my fear?** *I am afraid of writing this book.*

2. **Where did this fear stem from?** *I'm not a writer. Most authors have been writing for years and have a huge following that supports their work.*

3. **What type of fear is this?** *The fear that will hold me back.*

4. **What amazing thing will happen if I do push past this fear?** *I'll actually become an author and my words and experience will hopefully change someone's life.*

5. **What's the worst that could happen if I pushed**

past this fear? *No one buys it. (BUT I STILL WROTE THE BOOK!) And I will have a clear idea of what I can do to get people interested based on what didn't work before.*

6. How will I feel if I stop allowing this fear to control me? *Empowered, hopefully, fulfilled.*

7. What can I do to move past this fear?

- Keep a list of all of the reasons why I should write this book

- Create a to-do list of what needs to be done to write the book

- Reach out to a friend to help hold be accountable through the process

- WRITE THE BOOK!

FEAR ONE:

1. What is my fear?

2. Where did this fear stem from?

3. What type of fear is this?

4. What amazing thing will happen if I do push past this fear?

5. What's the worse that could happen if I pushed past this fear?

6. How will I feel if I stop allowing this fear to control me?

7. What can I do to move past this fear?

-
-
-
-
-

FEAR TWO:

1. What is my fear?

2. Where did this fear stem from?

3. What type of fear is this?

4. What amazing thing will happen if I do push past this fear?

5. What's the worse that could happen if I pushed past this fear?

6. How will I feel if I stop allowing this fear to control me?

7. What can I do to move past this fear?

-
-
-
-
-

FEAR THREE:

1. What is my fear?

2. Where did this fear stem from?

3. What type of fear is this?

4. What amazing thing will happen if I do push past this fear?

5. What's the worse that could happen if I pushed past this fear?

6. How will I feel if I stop allowing this fear to control me?

7. What can I do to move past this fear?

-
-
-
-
-

Acknowledgements

When I first started on this roller-coaster ride of launching a new online platform while also in the middle of writing a book, I reached out to my community for their support to help me get my ideas off of the ground. And the support has been incredible. The purpose behind the Living Over Existing brand is to support other women who are digging deeper into what they are being called to do, so it is only right that I acknowledge the incredible women who helped make this book and brand possible.

CHAMEL EVANS

Faith Mentor/Designer for Christian Creatives and Entrepreneurs

chamelevans.com

SIOBHAN SUDBERRY

Clarity Cultivator - Teaching Women How To Get Unstuck

befreeproject.com

ANNALISA COLEMAN

Digital Marketing Strategist

annalisa.co

CHAKAYLA TAYLOR

Goal Success Coach

chakaylajtaylor.com

LASHAWN HENIGHAN

Fitness Strategist and Motivator

itsshawn.com

MEGAN ELLIOTT

Web Designer

lushdesignshop.com

ASHLEE NICOLE

Web Designer & Brand Strategist

ashleenicoleartistry.com

LYNDA D. MALLORY

Author/Blogger

alifewithaviewblog.net

NAILAH HARVEY

Author and Copy Editor

nharv.com

BRITTANY HARRIS

Virtual Assistant

blossomingbrittany.co

GIRL BE FREE

Online Shop

girlbefree.com

ASHLEY SHARIE

Mindset + Business Strategist

2aspire.co

SAMANTHA E. MCCOY

President & Chief Strategist

missionkeycommunications.com

About The Author

Alisha Robertson is a clarity coach, self-published author and the founder/host of Living Over Existing, an online platform and podcast dedicated to helping creative women live their life and create their business on purpose.

Through her work, Alisha empowers women to uncover their voice, ditch fear, gain clarity & begin making money doing what they love. Alisha currently resides in Raleigh, North Carolina with her husband, Johnathan and their beagle, Porkchop.

Connect With Alisha

Personal Website & Blog: www.TheAlishaNicole.com

Twitter: @TheAlishaNicole

Instagram: @TheAlishaNicole

Facebook: facebook.com/thealishanicole

About Living over Existing

Living over Existing is an online platform for creative women who are wanting to live their life & create their business on purpose.

Whether you are looking to take the leap into turning your idea into a profitable business, wanting to take your current brand to the next level or you're simply just figuring out what's next, Living Over Existing is an online platform dedicated to showcasing the journeys of creative women from all different backgrounds and industries and how they are choosing to live on purpose.

We believe that authentic storytelling is powerful; It builds community, motivates you to take action and proves that you are not alone. The purpose of this online space is for you to learn from the stories of other powerful women from all walks of life, be motivated to dig deeper into what you are called to do and be provided with the necessary strategies needed to begin making money doing what you love.

Connect With Living over Existing

Website & Podcast: www.LivingOverExisting.com

Twitter: @LiveOverExist

Instagram: @LivingOverExisting

Facebook: facebook.com/livingoverexisting

Community: bit.ly/loecommunity